TWIN CITIES BEER

TWIN CITIES BEER

A Heady History

SCOTT CARLSON

AMERICAN PALATE

Published by American Palate
A Division of The History Press
Charleston, SC
www.historypress.com

Copyright © 2018 by Scott Carlson
All rights reserved

First published 2018

Manufactured in the United States

ISBN 9781467137058

Library of Congress Control Number: 2018932091

To my mother, Joan Carlson, who instilled in me a love of learning.

To my wife, Betsy (Becker) Carlson, my faithful, supporting and loving companion.

To all the homebrewers who have gone on to start up their own commercial microbreweries.

CONTENTS

PREFACE

In the last few years, the Twin Cities have witnessed an explosion of new craft beer breweries and brewpubs dotting the business landscape. As of the publication of this book, there are more than fifty microbreweries up and running in the St. Paul–Minneapolis region. The trend has been buoyed by changes in state laws that now give smaller-scale brewers the latitude to set up taprooms on their premises so they can easily and immediately generate revenue to support their businesses rather than being bound first to get expensive distribution systems in place.

Meanwhile, the burgeoning numbers of microbreweries also have been bolstered by a growing public acceptance, willingness and desire to stray beyond big-name, mass-produced brands and dabble in the delight of expanding taste buds into the craft beer craze.

But the surging interest by Twin Citians in craft beers and microbreweries is *not* occurring in a mystic vacuum. The simple truth is the Twin Cities have a rich tradition of brewing and breweries that dates back to the mid-1800s. We have been home to some of the best-known brands in America—from Hamm's and Schmidt's to Grain Belt and Olympia. Other names are associated with the beer brewing tradition—Gluek, Yoerg, Brueggemann and Schell. Today, we see remnants of those past majestic beer brewers, their mass production facilities starting to take on new life with, in some cases, distilleries, microbreweries, aquapond production, commercial offices and residential apartments.

In Minneapolis, the Grain Belt Beer sign sits just hundreds of feet outside of De La Salle High School on Nicollet Island, visible to thousands of commuters who cross the Mississippi River via the Hennepin Avenue Bridge every day. For more than seventy-five years, the forty-foot-tall sign, with its steely wires hoisting the familiar bottle cap, has been welcoming western travelers into downtown Minneapolis.

Brewing in Minneapolis dates back to the 1800s with the Minneapolis Brewing Company, which introduced Grain Belt beer into the city in 1893. The golden ale was brewed in the original Grain Belt brewery until 1976. After a series of other owners, August Schell Brewing Company took over in 2002, and Grain Belt was produced out of New Ulm, Minnesota, until 2015. The sign remains a fixture of Minneapolis, the dominant domicile for Minnesota brewing.

Some of the earliest records show that German-born Gottlieb Gluek started the Mississippi Brewery in 1857 at Marshall Street and Twenty-Second Avenue NE along the river just north of the city. The brewery burned to the ground in 1880 and spurred Gluek's sons' creation of the Gluek Brewing Company, which survived Prohibition but was sold and dissolved in 1964. Today, the Gluek label has been revived and is available in general distribution beyond the longtime Minneapolis restaurant of the same name.

Minneapolis has still successfully established its own identity as a welcoming—and consuming—home for microbrewers, whether that be in one's kitchen or in a cohort's bar. Although only two of Minnesota's five biggest breweries are in Minneapolis, more than twenty microbreweries have established themselves in the city limits and immediate suburbs, and their beers are fixtures in the one-hundred-plus bars found around the city.

Big players in Minneapolis like Surly Brewing Company produce thousands of barrels per year and are easy to find. But quaint, unique bars like Republic—which serves more than twenty taps of local brews you maybe knew existed or tasted—help cultivate the distinctive microbrewery scene along the Mississippi River's northernmost big metro community.

Meanwhile, in neighboring St. Paul, the Saintly City has a long history of breweries as well. That tradition dates back to the early 1800s and the days of Pierre "Pig's Eye" Parrant, an early fur trapper/settler who was a part-time bootlegger and established his own tavern along the banks of the Mississippi River. And in 1848, William Yoerg put down roots for a brewery along St. Paul's Mississippi River bluffs, making it the oldest commercial brewery in the state. With the drilling of artesian wells, two major breweries

sprang up in St. Paul—the Jacob Schmidt brewery (in St. Paul's West Seventh community) and the Hamm's brewery (tucked in on the south end of St. Paul's East Side).

Currently, Minnesota is sixteenth out of the fifty states in the number of breweries and craft breweries per capita, with most of the state's sixty-plus brewhouses residing in the Minneapolis area.[1]

Of the craft beer phenomenon, Bad Weather Brewing co-founder Zac Carpenter said, "I look at craft beer as more than a product on shelves. Craft beer is a device that fosters community and socialization. Just about anyone can find something to talk about while having a beer."

St. Paul and its suburbs also are getting in on the action with the establishment of such microbrewers as Barley John's Brew Pub, Flat Earth Brewing and Pour Decisions Brewing Company in Roseville (now renamed and operating as Bentbrewstillery).

My own recollections of the Twin Cities breweries were first as a boy who loved following the new Minnesota Twins in the 1960s and knew that Hamm's, with its iconic bear and familiar advertising jingle (more about that later in this book), was a major sponsor of the baseball team's TV and radio broadcasts. Nestled in St. Paul's Italian district on the city's East Side, my nostrils would be filled with the smell of brewing from the Hamm's plant when my parents would take my brother and me for spaghetti dinners at the old Geno's spaghetti joint.

Later, as an adult, I was part of the team of *St. Paul Pioneer Press* reporters who chronicled the closing of the Schmidt plant and later the Olympia plant (formerly Hamm's brewery). I witnessed firsthand how the plant closings hurt employees, many of whom were second- and third-generation family brewery workers.

In pulling together this book over the past year, I chose not to discuss the process of brewing beer or examine the brewing history across all of Minnesota. That's already been ably done in such tomes as Doug Hoverson's fine book *Land of Amber Waters: The History of Brewing in Minnesota* (University of Minnesota Press, 2007). Rather, I endeavored to give you, the reader, a snapshot of the Twin Cities' rich history of brewing and breweries, yesterday and today.

I hope you find my book a quick, engaging read, one that you feel free to tuck in your backpack or knapsack as a reference resource when you are out on a pub crawl.

Happy reading and cheers to your beer adventures.

ACKNOWLEDGEMENTS

The Twin Cities' rich tradition of commercial beer brewing has been around for more than 150 years. During that time, there have been boom and bust cycles, with the brewing culture today busy and on the upswing again.

The stories that follow on the subsequent pages of this book would not have been possible without plumbing many sources. For some of the best information on the Twin Cities' earliest brewing history, I found outstanding background from author Doug Hoverson and his book *Land of Amber Waters*. Also particularly helpful to me for a look at some of St. Paul's earliest brewing lore was Gary Brueggeman's article "Beer Capital of the State—St. Paul's Historic Breweries."

The archives of the Minnesota Historical Society also proved to be helpful, particularly in locating old photographs.

Meanwhile, I conducted primary and web-based research on upward of nearly fifty microbreweries now in the Twin Cities region. The many young entrepreneurs in the craft beer world were enthusiastic and particularly helpful in providing information and supporting my project. At the risk of missing someone, I want to give a special shout out to Mark Stutrud of Summit Brewing, Thomas Keim of Yoerg Brewing Company, Bartley Blume of Bent Brewstillery, Jeff Moriarity of Tin Whiskers Brewing Company, Dan Justesen of Utepils Brewing Company, Robert Klick of Wayzata Brew Works and Evan Sallee of Fair State Brewing Cooperative. Additionally, Matt Kenevan of the Beer Dabbler gave me great insights into the world of beer festivals.

Of course, a cast of many people helped get me to this point in life where I could even consider writing books. They include my parents, Joan and Roger Carlson; high school journalism teacher Harold Cantor; a string of *St. Paul Pioneer Press* editors, including Ben Chanco, Steve Smith, Walter Middlebrook, Dave Beal and Chris Worthington; and my wife, Betsy Carlson. I also wish to give a nod to my brother, Doug Carlson, and my children, Thomas and Margaret Carlson, who have given me moral and prayer support through the years in my endeavors.

Finally, special thanks to the staff at The History Press for helping me to get this book ready for publication. To Banks Smither, my acquisition editor at The History Press, for his patience in helping me organize my photos for this project and for reviewing my manuscript and providing deft editing assistance. To Abigail Fleming, who assisted in editing my manuscript. And a shout out to Erin Owens, a History Press marketing specialist, for her work in helping promote my book.

1

ST. PAUL BREWING

The Legend of Pig's Eye Parrant and the Early Years

The city of St. Paul was destined to become home to some of Minnesota's earliest breweries.

After all, the origins of St. Paul were linked to a scruffy, retired fur trader named Pierre "Pig's Eye" Parrant. He was one of the area's first European settlers and ran a "whiskey settler's cabin" at the mouth of Fountain Cave (which is located near the current intersection of Shepherd Road and Randolph Avenue). The cave had clear, cold streaming water flowing through it, and from that location, the irascible Parrant found a convenient spot to sell bootleg whiskey to soldiers at nearby Fort Snelling and Indians "without the pale [interference] of a law."[2]

Parrant had an eye patch and he was nicknamed "Pig's Eye" because his good eye had a white ring around the pupil that was said to give it a piggish expression. From Pig's Eye Landing, where Parrant ran a popular tavern beginning in 1838, this area would go on to be renamed St. Paul. Fifty years later, St. Paul was a part of Minnesota's strong brewing tradition boasting 12 breweries among some 112 in the state.

The region boasted mighty brewing prowess: Minnesota ranked fifth for beer production in the nation while it was the twentieth largest state based on population. The beehive of brewing activity in the city (and also across Minnesota) meant St. Paul was ripe to become a beer capital not only because of its ample fresh water supply and fertile conditions for growing hops and barley—key beer ingredients—but also because it was populated by a large influx of German immigrants, who brought with them their culture for lagers and brewing.

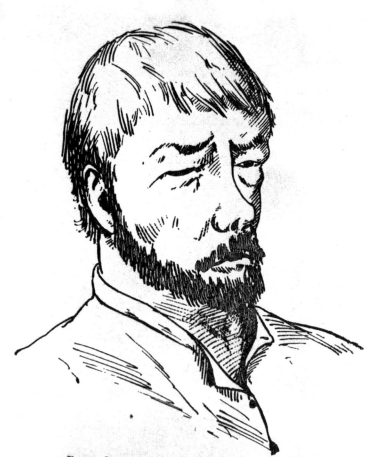

Drawn from remembrance of a physiognomist.

PIERRE PARRANT, OR "OLD PIG'S EYE."
First settler in St. Paul, in 1838.

Artist's rendition of Pierre "Pig's Eye" Parrant, an early settler who ran what was the first tavern in St. Paul in 1838. *Minnesota Historical Society.*

"Their culturally-induced mass thirst for 'bier' not only provided the demand for brewing, but German technology with its innovative methods of fermenting also provided the best process of brewing," according to Brueggeman. "Created by a different type of yeast, along with a different preparation method (aging of the brew in a cold place), lager beer had a cool, light, foaming quality that, to many people's tastes, far excelled the common English ales and Porter beer."

Meanwhile, another thing that made St. Paul conducive to brewing was that it had a large number of cool caves that were ideal for aging beer:

> *In the pre-electric world of 19th century brewing, underground refrigeration was a necessity. St. Paul's Mississippi river bluffs not only provided a number of deep caves, but the soft texture of these sandstone terraces made it relatively easy to artificially create cooling caverns. Thus, in St. Paul, brewers were spared the expense in time and money of building costly brick cold cellars—a savings that was particularly helpful to small-time operators with little capital.*[3]

In its early years, St. Paul had slightly more than a dozen local breweries that made use of the city's sandstone terraces. Here's an overview of some of St. Paul's best known and significant breweries.

THE YOERG BREWING COMPANY

German immigrant Anthony Yoerg built and started operating a brewery in St. Paul in 1848, the year before Minnesota became a territory. Yoerg was just thirty-two years old when he started the brewery, leaving his previous employ as a butcher. His career switch proved fortuitous for Yoerg, as he went on to "build one of the most successful breweries in Minnesota history."[4]

Yoerg's Washington Street brewery (the only one in town until 1853) was a small-scale operation but functioned successfully for twenty-one years in St. Paul's heavily German Uppertown around Seven Corners. (Today, that location is at the corner of the Xcel Energy Center at Kellogg Boulevard and West Seventh Street.)

In the early 1870s, Yoerg moved his business across the Mississippi River to the west side bluffs near Ohio Street (another German neighborhood), two blocks south of today's Water Street. There Yoerg built a vast stone brewery consisting of three buildings, and he carved out nearly a mile of underground cooling caves. From this site, his company had a modern, steam-powered, assembly-line beer factory that could produce more than fifty barrels of brew a day. By 1881, Yoerg's facility was producing twenty thousand barrels of beer a year, and by 1891, it had risen to thirty-five thousand barrels a year, Brueggeman noted.

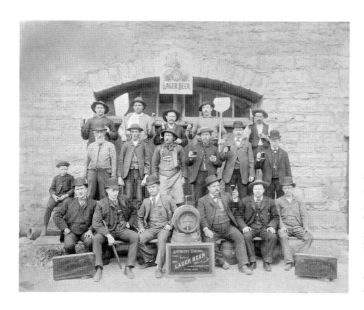

The staff of the Yoerg Brewing Company, the Twin Cities' first commercial brewery, circa 1870. *Thomas Keim and Minnesota Historical Society.*

At the close of the 1800s, Minnesota's first brewery was also one of its largest. "Yoerg's Cave Aged Beer" (its official label) was distributed throughout "Minnesota in both kegs and bottles. The kegs were made right on the brewery's premises in the company's own cooper shop."[5]

Like most of St. Paul's original breweries, the Yoerg Brewing Company was a family-run business. Yoerg and his wife, Elovina, ran the company in its earliest years. When Anthony Yoerg died in 1896, his sons succeeded him in the brewing company. It was Yoerg Sr.'s third-eldest son, Frank, who served as company president from 1905 to 1934 and then secretary from 1934 until his death in 1941.

Another Yoerg brother, Henry, was vice-president of the brewery on two different occasions, serving in that capacity interspersed between his mechanical engineering career. (He was superintendent of the Great Northern Railroad's shops.) Anthony Yoerg's youngest son, Louis E., also served in the brewery, where he held the post of secretary-treasurer from 1896 to 1935 and then president from 1935 until his death in 1950.

When Yoerg's Brewing Company ceased business in 1952, the president of the 103-year-old firm, Alfred Yoerg, the son of Anthony Jr., represented the third generation of Yoerg brewers.

Today, one reminder of St. Paul's West Side institution is the brewery's cave and foundation ruins toward the bottom of Ohio Street and the beautiful former estates of Anthony Sr. and Jr. at 215 and 235 West Isabel Street.

In addition, the Yoerg brand has been resurrected by Thomas Keim, a Twin Cities wine and beer broker; his story appears in a subsequent chapter in this book.

Brueggemann's Brewery

Brueggemann's Brewery began operations in 1853 and was a hand-operated, small-scale facility run by Martin Brueggemann, a twenty-five-year-old Prussian bachelor, at what today is Smith and Kellogg Boulevards.[6]

After just a few years in business, Brueggemann's wood brewery burned down. He replaced that plant with a stone structure at the corner of Sixth and Pleasant, the neighborhood of Minnesota's first German Catholic parish—Assumption Church. It was here that Brueggemann struck up a friendship and business partnership with Alex Schweitzer; the two men's brewery produced small quantities of beer there until Schweitzer left town in 1864 and Brueggemann took over again as sole owner.

In 1872, Brueggemann moved his brewery across the Mississippi River at the base of the sandstone cliffs west of Wabasha Street, within almost a stone's throw of the Yoerg Brewing Company. The Brueggemann brewery remained at 22 Channel Street for more than twenty-five years.[7]

Brueggemann's Brewery used the adjacent sandstone caves for aging and refrigeration purposes. In the early years, the brewery produced only a couple thousand barrels of beer per year, but that was enough brewing activity to turn a decent profit, enabling Brueggemann to support his wife and ten children and also make significant donations to support construction of St. Matthew's Catholic Church, a German parish on St. Paul's West Side, according to Brueggeman (no relationship or descendant to the brewery owner).

Martin Brueggemann died in 1897, and his son John carried on the brewery business until it closed in 1900. John dissolved the company and sold the facility to the Aiple Brewing Company, which used the site until 1905.[8]

Today, there are few reminders that Brueggemann's Brewery ever existed. Its only traces are a few relics, including the sandstone caves formerly used and a beer bottle owned by a member of the North Star Bottle Club.

North Mississippi Company

Founded in 1853 by an obscure beer maker named "Mr. Rowe," the North Mississippi Company's brewery resided on the east side of the Mississippi River bluffs near what today is the junction of Shepard Road and Drake Street in St. Paul's West Seventh Street neighborhood.

In its early years, the North Mississippi Company had several owners and limited success. The brewery's most significant figure was Charles Rausch, a German who bought the facility for $45,000 in 1859 after cashing out from the sale of his successful restaurant, the Apollo Hall, St. Paul's first restaurant.

Bad luck befell Rausch when shortly after he took over the brewery, a worker fell into a hot vat of beer and was boiled to death. The freak accident cast a pall over the brewery as "rumor quickly circulated around the city that Rausch's beer was contaminated with human skin. In spite of his efforts to squelch the rumor, beer sales continued to drop and Rausch was ultimately forced to sell the brewery at a great loss in 1865."[9]

North Mississippi's fortunes didn't improve much after Rausch's exit. During the first year under its next owner F. A. Renz, the plant caught on fire.

Eventually, however, a German man and his son, Frederick and William Banholzer, respectively, revived and reconstructed the North Mississippi brewery in 1871. Son William had a keen interest in brewing. He bought out his father's brewery interest in in 1878.[10]

A heavyset man with a handlebar moustache, William Banholzer was instrumental in turning the one-thousand-barrel-a-year brewery into a twelve-thousand-barrel operation. The company's facilities included nine buildings and a half-mile-deep, multi-chambered cave. Today, this cave still runs from the riverbank, under Shepard Road, to the vicinity of Butternut Street. The old stone archway at the lower entrance is a visible and lasting reminder of Banholzer's brewery.

The financial success of the North Mississippi Company was evidenced by the prosperity of its owner, William Banholzer. "In 1885, he built a grand stone house at 689 Stewart Avenue for $10,000, a huge amount of money in 1885," according to Brueggeman. "The still-standing mansion is one of the more impressive 19th century houses in St. Paul, a testimonial to the success of the North Mississippi Brewery."

However, William Banholzer's death at age forty-eight in 1897 also signaled the demise of the brewery. William Banholzer's sons (six in all) were all too young to assume management of the company. William's demise left his

forty-three-year-old widow, Louise, to preside over the business. Ultimately, that task proved too tough for Louise and the brewery closed.

Brueggeman noted that in 1855, three more breweries came to St. Paul. They were, as follows:

City Brewery

Founder Dominick Troyner, a German immigrant, built a small one-and-a-half-story stone and wood facility near Eagle and Exchange Streets, in the heart of Uppertown. The brewery used the adjacent sandstone hill for its refrigeration caves. Traces of these caves can still be seen inside the Exchange Street tunnel below Kellogg Boulevard. Troyner operated City Brewery for only five years. In 1860, he returned to visit Europe and sold the enterprise to William Funk and Ullich Schweitzer (perhaps the brother of Martin Brueggemann's former partner.)

Funk and Schweitzer, two native Germans, owned the brewery until 1866, when William Funk sold his interest to Frederick Emmert, who would become synonymous with City Brewery. A short, fiery, red-haired and bearded man, Emmert had made most of his money in the hotel and saloon businesses. Born in Germany in 1831, he immigrated to the United States in 1849 and, in the span of four years, lived in six different cities before he arrived in St. Paul in 1854 and became involved in the hotel and salon businesses.

Emmert made a major impact on City Brewery. When he first entered the business in 1865, the brewery was a small-time company, struggling to compete against eight other local beer makers. But by 1878, Emmert's City Brewery (Emmert bought out Funk in 1871) rose to become St. Paul's second-largest brewery, according to Brueggeman. Although the 1880s would see other local breweries surpass his in production, Emmert's City Brewery remained a steady six-thousand-barrel-a-year enterprise until the turn of the century.

During his brewing career, Frederick Emmert had several famous friends including Alexander Ramsey, Minnesota's first governor. (Ramsey, who was part German, lived near Emmert on Exchange Street and the two were also fellow members of both the Athenaeum German Hall and the Republican Party.) He also considered Otto von Bismarck a good friend. (Emmert met the famous "unifier of Germany" in 1885 during his vacation to Germany and was a guest at his castle.)

When Frederick Emmert, fifty-eight, died in 1889, he left behind sons Fred, William and Charles, who were all educated and experienced brewery men. The three brothers kept the family business going for twelve more years. In 1890, they honored their father by changing the business's name from City Brewery to the F. Emmert Brewing Company. During the 1890s, the brewery catered to the large saloon district on Eagle Street. Dozens of bars lined the hillside from Seven Corners to the levee. In fact, Charles Emmert owned one of the saloons, a colorful drinking spot at 301 Eagle Street that was known as the "Bucket of Blood" because of its many barroom brawls.

After forty-six years in business, the brewery closed its doors for good in 1901. The Emmert brothers pursued other careers and sold the facility to the Theo Hamm Brewing Company of St. Paul. That transaction enabled the Hamm Company to buy out a tough competitor, and the Emmert brewery simply became a storage area.[11]

STAHLMANN'S CAVE BREWERY

Christopher Stahlmann's Cave Brewery opened in the summer of 1855, in what was then the western edges of St. Paul and a rural wilderness paved only by a wagon trail named Fort Road. Stahlmann was probably drawn to this out-of-the-way spot because of its cool natural springs and caves, Brueggeman noted.

The caves, which still exist under West Seventh Street, were eventually excavated by Stahlmann (at a cost of $50,000) to reach three levels in depth and a mile in width. An 1883 business publication described the caverns as follows: "A perfect labyrinth of rooms and cellars and under cellars three deep, reminding one of the catacombs of Rome, for none unacquainted with these subterranean vaults, without a guide, could grope their way through them and find their way out to daylight."

Christopher Stahlmann, founder and developer of Cave Brewery, was known for his business acumen and civic activity. He was born to a wealthy family in Bavaria in 1829, but due to his father's bankruptcy, he emigrated to America in 1846 with only "five dollars in his pocket!"[12]

Stahlmann made some intermediary stops before he and his Iowa bride, Katherine Paulas, moved to St. Paul, in 1855 "with just a few dollars."[13]

From his miniscule financial resources, Stahlmann created an enterprise that quickly became the largest brewery in Minnesota. According to available

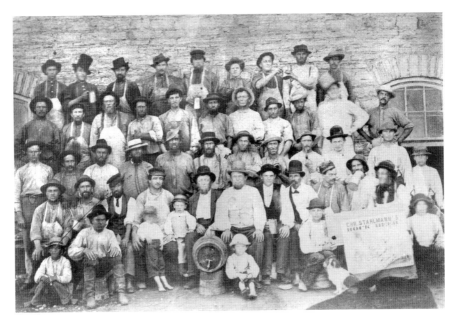

Workers from Stahlmann's Brewery, one of St. Paul's original breweries that operated during the second half of the 1800s. *Minnesota Historical Society.*

beer production records for the years 1867–79, Stahlmann was the number one beer maker in the state. (He averaged more than 10,000 barrels of beer per year.) "Although Stahlmann lost his No. 1 ranking in the mid-1880s, his brewery continued to increase production, reaching a peak of 40,000 barrels a year by 1884," Brueggeman noted.

On December 3, 1883, at the peak of his career, Christopher died of tuberculosis. At that time, Stahlmann's brewery was generating $250,000 a year in sales, an immense amount of money in that era. His brewery plant included five three-story buildings on sixty lots, two large steam engines, three boilers and forty-seven employees.[14]

The inheritors of Stahlmann's thriving enterprise were his wife, Katherine, and their three sons, Christopher Jr., Henry Conrad Gottlieb and Bernard U. All three sons were experienced brewery workers, capable of carrying on their father's work. Chris and Henry C.G. had each served as the firm's treasurer, while Bernard served in a variety of clerical jobs.[15]

Sadly, the same disease that killed their father also struck all of the Stahlmann brothers. Tuberculosis claimed the lives of thirty-one-year-old George and twenty-six-year-old Bernard in 1887 and Christopher A.J. Jr. in 1894.

During this tumultuous decade of 1884 to 1894, the brewery's presidency fell into the hands of Henry Conrad Gottlieb's father-in-law, George Mitsch Jr. (1854–1895), a native German and the founder of St. Paul's Catholic Aid Society. Mitsch, a blacksmith by trade and a druggist by desire (as well as a former legislator and councilman), was unable to lead the brewery through the disaster of losing four key executives.[16]

In 1897, the Stahlmann Brewing Company went bankrupt and its last president, Charles J. Dorniden, sold the plant to a new enterprise, the St. Paul Brewing Company.[17]

The company lasted only three more years. In 1900, the Jacob Schmidt Company (formerly North Star Brewery) bought the entire Stahlmann Brewing facility, including the grand stone mansion of founder Christopher Stahlmann at 855 West Seventh Street.[18]

THE SCHMIDT COMPANY

St. Paul historian Brueggeman noted this company's roots were in the caves of Dayton's Bluff, near what was once Hudson Avenue. Working from that site, the North Star Brewery began business in 1855 under the ownership of Mr. Drewery and Mr. Scotten.

The brewery had changed ownership twice when it wound up in the hands of a Frenchman named William Constans in 1872. In 1879, Constans teamed with Reinhold Koch, a Civil War veteran who had been foreman at Stahlmann's, to form Koch and Company.

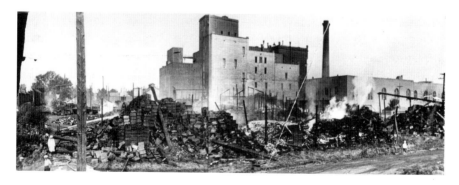

The Schmidt brewery sustained minor damage in a fire in 1925. *Minnesota Historical Society.*

By the 1880s, the North Star Brewery was "the second largest brewery west of Chicago," producing sixteen thousand barrels a year. During this period, Jacob Schmidt joined the North Star firm.[19]

Born in Bavaria, Schmidt was an experienced brewmaster whose résumé included stints at the Best, Blatz and Schlitz breweries in Milwaukee as well as the Schell brewery in New Ulm and Banholzer and Hamm's breweries. In 1884, Schmidt bought out Koch's interest in the brewery to gain control of the company.[20]

The Schmidt Company would go on to be one of St. Paul's largest and most successful commercial brewers.

Other Breweries

Brueggeman, in his article, noted St. Paul had several other notable breweries in its early days:

Melchoir Funk Company (1865–1901) was founded by German-born Melchoir Funk (1828–1893) and continued by sons John and William. The two-thousand-barrel-a-year enterprise was located near Colborne and Palace. Melchoir's home at 398 Duke Street, built in 1887, still stands as a reminder of this brewery.

Conrad Wurm's (1863–1889) was founded in 1863 by German-born Conrad Wurm (1819–1877) and carried on by his widow, Johanna (1823–1894). It produced around four hundred barrels a year.

Frank Hornung's (1876–1883) started near the original Yoerg's brewery and produced about two hundred barrels annually. Hornung, a native of Wurttemberg, Germany, and an ex-Stahlmann worker, died in 1893.

Drewery's Brewery (1861–1913) was founded by Englishmen Putnam and Dexter and sold to Edward Drewery in 1866. This brewery was located at 702–10 Payne Avenue (now Drewery Avenue). It specialized in English porter and ale. Edward Drewery was the former owner of the North Star Brewery, which he sold in 1866.

Joseph Hamm and John Reimer's Company (1885–1887). For two years, Reimer and Hamm ran a brewery at Joy Avenue near Lilydale Road. Joseph Hamm had been the foreman at Brueggemann's Brewery.

MINNEAPOLIS BREWING

John Orth to Grain Belt

S t. Paul wasn't the only town to lay claim to Minnesota's earliest days of commercial brewing. A few miles upstream along the Mississippi River, the city of Minneapolis also had its share of players participating in the region's beer scene.

Brewing history is everywhere in Minneapolis's Northeast district. "Part of the reason Northeast ends up being where Minneapolis' brewing industry is centered is not necessarily because of any great ethnic tradition up there," said Twin Cities beer historian Doug Hoverson. "It was simply that side of the river was the first side to be open to settlement, and was so by a good 10 years." This area also had some logistical advantages, including access to the river for shipping, springs for clean water and bluffs that made for good lagering caves.

John Orth, a twenty-nine-year-old German immigrant, arrived in the Minneapolis–St. Anthony area in July 1850. In November of that year, he opened a brewery at 1228 Marshall Street, the second such facility in the state. Orth came with a bounteous beer background, first learning brewing in France and then honing those skills in Germany, Italy and Spain before immigrating to the United States in 1849.[21]

Orth believed the drinking public would find his beers worthy of their patronage. In papers from the John Orth and Family Collection at Hennepin County Library/Central Library, Orth is quoted as saying, "I am now ready to supply the citizens of this Territory with Ale and Beer which will be found equal—yes, superior—to what is brought from below.

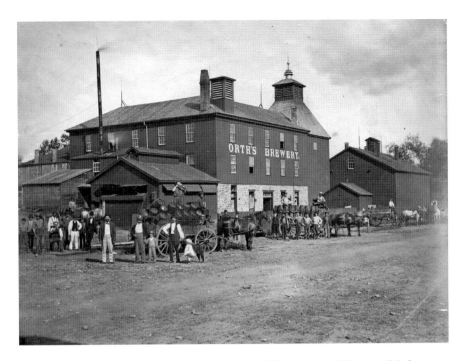

The Orth Brewing Company opened in November 1850, serving as Minneapolis's first commercial brewery. *Minnesota Historical Society.*

I am now demonstrating that malt liquors of the very best quality can be manufactured in Minnesota."[22]

Apparently, locals agreed with Orth's assessment. Orth Brewing Company grew from a capacity of one thousand barrels in 1860 to seven thousand barrels annually by the late 1870s. His company kept its beer cool by storing it in a cave on Nicollet Island and later an ice cellar, which Orth used for lagering beer. Orth moved his operations in 1880 to 1215 Marshall Street NE.[23]

GLUEK BREWERY

Nearby, another Minneapolis brewery was ready to burst onto the scene. Gottlieb Gluek, another German immigrant, arrived in Minneapolis in 1855. He worked for John Orth until 1857, when he established the Mississippi Brewery at Marshall Street and Twenty-Second Avenue NE.

Gluek Brewing Company opened in 1857 at Marshall and Twenty-Second Avenue, and the Lauritzen Brewing Company opened at 1900 Third Street NE in 1903. The latter brewery did not survive Prohibition, nor did any Minneapolis brewery located outside Northeast.

Gluek's brewery suffered a couple of traumatic setbacks in its early years. First, the brewery burned to the ground in the spring of 1880 and had to be rebuilt. Second, its founder, Gottlieb Gluek, died a few months later. Gottlieb's sons continued the business as G. Gottlieb & Sons, and later as the Gluek Brewing Company.[24]

But the Gluek enterprise began enjoying better days at the turn of the twentieth century. In 1901, Gluek's was third in annual beer production in the area, behind Minneapolis Brewing Company (now Grain Belt) and Hamm's Brewery. By 1902, the plant was turning out forty-four barrels a day.

A MEGA-MERGER

Back at the Orth Brewing Company, big changes were brewing. In 1887, John and his wife, Mary Orth, traveled to Europe and Africa, where they fell ill and died in transit. The Orth brewery, operated by the couple's three sons, continued as an independent brewer for three years after John Sr.'s death.

For the company to be competitive, the Orth brothers realized that production needed to be consolidated in one high-volume facility to produce at least 150,000 barrels a year, according to the Grain Belt Beer history website.

Orth merged with three other companies—the Heinrich Brewing Association, the Norenberg Brewery and the Germania Brewing Association—in 1893 as the newly incorporated Minneapolis Brewing Company. For a brief time, Minneapolis Brewing ran its operations out of the old Orth brewery, the largest of the four businesses, while a new, larger brewery was being built, according to Grain Belt Brewing history website.

Sporting four different architectural styles that represented the four original breweries; the Minneapolis Brewing Company brewery was a major community landmark. Considered then one of the largest and most modern brewing facilities in the country, its initial cost was $500,000 and had an annual production capacity of 300,000 barrels. Plant additions over the next

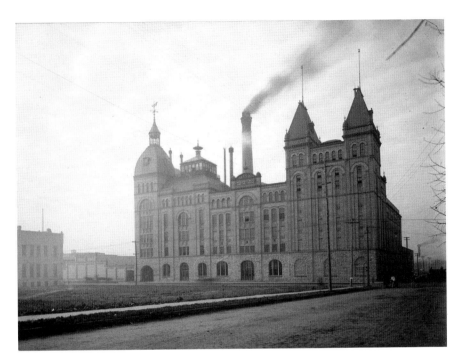

The Minneapolis Brewing Company sprang to life in 1893, the result of a mega-merger of four breweries: the Orth, Heinrich, Norenberg and Germania Brewing plants. *Minnesota Historical Society.*

decade brought production up to a half-million barrels per year. Wooden barrels and glass bottles of beer were transported for distribution from the brewery in horse-drawn wagons.[25]

In the *AIA Guide to the Twin Cities*, former *St. Paul Pioneer Press* architecture reporter Larry Millett called the brewery "Northeast's great architectural monument—a Victorian storybook of a building that erupts at the roofline into a dance of towers, domes, and cupolas."

Armed with the new brewery, the Minneapolis Brewing Company introduced a new line of beers under the Golden Grain Belt Beer trademark in 1893. The Golden Grain Belt label would prove to be immensely popular and become the company's signature trademark beer in succeeding decades. (The name Grain Belt referred to the geographical area of the nation where the beer was brewed. It was later promoted as "The Friendly Beer with the Friendly Flavor.")[26]

By 1905, Minneapolis Brewing Company was nearly self-sufficient, with facilities including a cooperage, a carpentry shop, a machine shop, a wagon shop, a paint shop and a livery.

With new opportunities also came new challenges for Minneapolis Brewing Company. During Minneapolis Brewing's first year in business, a fire started in a stable on Nicollet Island and spread quickly to north Minneapolis, destroying homes, mills, lumber yards, factories and properties in its path. The blaze reached the Minneapolis Brewing Company, whose $117,000 in estimated losses included its malt house, three bottling houses, a pitch yard and a barn.

Rebounding from the fire, Minneapolis Brewing continued to expand and grow as Minnesota entered the twentieth century. By 1910, it had become one of the largest beer producers in Minnesota, second only to the Theodore Hamm Brewing Company in St. Paul. By this time, Minneapolis Brewing was selling beer in Minnesota and seven surrounding states.

Then came national Prohibition in 1920. Minneapolis Brewing Company survived this period by selling soft drinks, malted drinks and near beer under the name of the Golden Grain Juice Company. Minneapolis Brewing Company resumed its alcoholic beverage business in the mid-1930s after Prohibition's repeal in 1933.

The 1950s were not kind to the Minneapolis Brewing Company and the industry in general. In a bid to rejuvenate business, the brewery introduced new labels as well as engaged in billboard and TV advertising. One of the most popular ads featured Stanley and Albert, a pair of cartoon sign painters who sang the praises of Grain Belt beer.

"But it would take more than slick advertising to revitalize the brand. In the early 1950s, Grain Belt Premium, a smoother, full bodied beer was introduced to attract the younger, more unpredictable consumer. Sales were positive and Premium became a permanent fixture on the Grain Belt line up in 1956."[27]

Eleven years later, in 1967, the company officially changed its name to Grain Belt Breweries after purchasing the Storz Brewing Company of Omaha, Nebraska, which marketed Storz Beer and Storz Tap Beer in bottles, cans and draft.[28] Grain Belt also took over the line of the New Ulm, Minnesota–based Hauenstein Brewery two years later.[29]

At the end of the 1960s, Grain Belt was the eighteenth-largest brewing company in the United States, and a major force in the Midwest, with local players Hamm's and Schmidt its primary competitors.[30]

In the early 1970s, Grain Belt sought growth through acquisitions and new beer introductions. But its strategy was an uphill battle against national brands like Anheuser-Bush that muscled their way into the market with saturation advertising and the deep discounting of products.

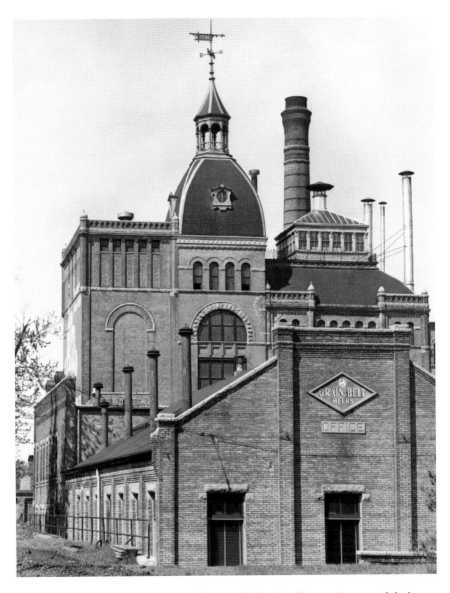

The Grain Belt Brewery (formerly the Minneapolis Brewing Company) operated during much of the twentieth century. *Minnesota Historical Society*.

In April 1975, Twin Cities businessman Irwin Jacobs borrowed $4 million and bought the Grain Belt brand; eight months later, he sold it to LaCrosse, Wisconsin–based G. Heileman Brewing Company, reaping a $4 million profit. Grain Belt was leaving Minnesota.[31]

Any revenue that Heileman gained from Grain Belt, for the most part, was diverted to promote its Schmidt brand. Heileman gave Grain Belt minimal promotion, and the brand's sales steadily declined through the 1970s and '80s.

Throughout its tenure, the Minneapolis Brewing Company remained independent until the company and the label were sold; the brewery permanently shuttered on Christmas Day 1975.

In 1987, the City of Minneapolis spared the Grain Belt building from the wrecking ball, buying the brewery site for an estimated $300,000.

Meanwhile, in the 1990s, Grain Belt saw some resurgence after returning to Minnesota. A group of investors bought the old Schmidt brewery in St. Paul just as Heileman was about to dismantle and scrap the equipment, rehired the employees and began operating as the Minnesota Brewing Company in late 1991.[32] In addition to the plant, the company purchased the Grain Belt labels from Heileman and brought back packaging that was similar to that of the old Grain Belt.

In 1993, Grain Belt celebrated its 100th anniversary.[33]

One highlight occurred in 1994 when Grain Belt was awarded the gold medal in the American lager category at the Great American Beer Festival in Denver, Colorado.

Grain Belt was sold in 1975 and changed hands a few times until the label was purchased by August Schell Brewing in 2002, which brews the beer today. (But the Grain Belt brewery itself stopped producing beer in 1976, ending Northeast's long brewing history.)

In 1989, G. Heileman, citing excess capacity, closed the St. Paul brewery and moved production of Grain Belt to its La Crosse, Wisconsin brewery, taking production of the Grain Belt (and Schmidt) brands out of the Twin Cities for the first time. G. Heileman found itself faltering within a decade because of many of the same market pressures Grain Belt Breweries had encountered in the 1970s.[34]

As fate would have it, Ted Marti of the August Schell Brewing Company saw the pride that Minnesotans had in the Grain Belt brand, and in 2002, he purchased the labels, keeping the proud heritage in Minnesota where it belongs.

In 2010, Schell's released its first brand extension of the Grain Belt label, introducing Grain Belt Nordeast. This beer pays tribute to the neighborhoods in northeast Minneapolis that still stand in the shadows of the original brewery.[35] In February 2016, August Schell Brewing Company, the Minnesota-based brewers of Grain Belt beer, completed the purchase of the iconic Grain Belt Beer sign on Nicollet Island.

Schell's acquisition of the giant Grain Belt billboard sign came fourteen years after it bought the Grain Belt brand. "The Grain Belt Beer sign both reflects and contributes to the downtown Minneapolis character as a historic industrial and commercial city," said Ted Marti, president and fifth-generation descendant of brewery founder August Schell. "As a historic Minnesota brewery, we're committed to preserving our history and the history of our state."

Minneapolis Brewing erected the iconic Grain Belt Beer sign in 1940, with its letters flashing in sequence "G-R-A-I-N B-E-L-T BEER." The overall dimensions of the sign are forty by sixty by one hundred feet. According to Schell's news release, the Grain Belt sign was last lit in 1975. At the end of 2017, brewery officials succeeded in getting the giant sign lit once again.[36]

Another significant Grain Belt fact: The brewery complex was added to the National Register of Historic Places in 1990.

Gluek Story

Meanwhile, Gluek Brewing not only survived Prohibition but also remained an independent brewery and quite successful for many years, continuing to grow in popularity. By 1941, Gluek's had gained 7 percent of the beer market in Minnesota, and just twenty years later, the company's beer was being distributed in twenty-seven different states.[37]

In 1964, the company was sold to G. Heileman, which demolished the Minneapolis brewery two years later. In 1997, Cold Spring Brewery bought the Gluek label from G. Heileman Brewing Company, which was its brewer until 2015. Now, Gluek's label has been given new life. More on that in the chapter on brewery resurrections later in this book.

Today, neither one of Northeast's original breweries exist. The Grain Belt brewery complex has been redeveloped into space for offices, artist studios and light industrial businesses.

"For decades, Minneapolis Brewing Company and Gluek Brewing Company were the only breweries in Minneapolis," Jeremy Zoss wrote in the *Growler* magazine in 2012. But in hindsight, both breweries struggled once national beer brands capitalized on TV advertising to penetrate the local market.

"Each was too small to compete with national brands, but too large to function solely as local breweries," Doug Hoverson told the *Growler* magazine.

"They were not viewed as trendy, modern, forward-moving beers. They were the beers that Grandpa drank. Especially in the 1950s, when it's all about being modern and the height of food was Wonder Bread, the height of beer was the lightest, cleanest beer with the least aftertaste. The beer that Grandpa drank wasn't cool."

3

PUSHING THROUGH
PROHIBITION

W hen Prohibition took effect in 1920, the new federal constitutional ban on the production, transportation and sale of intoxicating liquors came upon Twin Cities breweries like an oppressive summer heat wave. Commercial breweries had no idea if or when Prohibition would come to an end.

In *Land of Amber Waters: The History of Minnesota Brewing*, Doug Hoverson chronicles how the temperance movement had gathered steam for several years before Minnesota's ratification of the Eighteenth Amendment.[38] Given that backdrop, some of the Twin Cities' most prominent brewing companies were bracing for a change and shifted gears.

At the Yoerg Brewing Company, brothers Louis and Frank Yoerg guided the company in changing over to soft drink production and then switching back to beer once Prohibition ended in 1933.[39]

Schmidt, Hamm's and Minneapolis Brewing (later known as Grain Belt) breweries also turned to producing soft drinks and other nonalcoholic products, such as milk, to survive the dry spell of the long Prohibition years. The Schmidt's strategy included producing "near beers" like City Club and Malta.

Meanwhile, the Minneapolis Brewing Company started a subsidiary, the Golden Grain Juice Company, to make, buy and deal in non-intoxicating beverages, according to the Grain Belt history website:

Golden Grain Juice Company's primary product was near beer, a malt beverage with no more than 0.5 percent of alcohol. A ninety-foot still was built in the brewhouse, which included the de-alcoholizing unit. Made like regular beer, the brew was boiled down in the still, with the alcohol extracted and stored in tanks under government seal. The near beer was marketed primarily under the name Minnehaha Pale.

Initially, juice sales were promising, but they quickly faded, as real beer was still readily available from bootleggers or from anyone who took the time to make their own brews. For example, "In the Twin Cities, false basements with hidden booby-hatch entrances were used to store kegs and serve as after-hours speakeasies," the *Star Tribune* reported in a November 2013 story about a traveling Prohibition exhibit scheduled to appear at the Minnesota History Center. "Shaw's in northeast Minneapolis still has a trap door behind the bar that leads to a musty old underground hideout."

Additionally, there was a question of what to do with extracted alcohol from the making of near beer—at first, it was stored in locked tanks occupying space in the brewhouse. Minneapolis Brewing formed the Kunz Preparations Company (named after general manager Jacob Kunz) to use the extracted alcohol to make rubbing alcohols, toilet preparations and barber supplies.[40] But these endeavors proved to be pricey, as they came with high government permit fees.

ALL BREWERIES NOT ADAPTABLE

Not all Twin Cities breweries found a work-around to Prohibition. For example, Hoverson reported, "Gustav Kuenzel, of Hastings Brewing Co. turned down a chance to make soft drinks and moved with his equipment to Kenora, Ontario."

As for whether active brewers remained on the good side of the Prohibition laws was a big question. Hoverson noted, "The degree to which breweries continued to brew full-strength beer during Prohibition is unclear.…Rumors concerning Schmidt Beer Company brewing strong beer and shipping it out through a network of tunnels have been popular in St. Paul for many years, but no firm proof has been offered."[41]

Whatever the case, when Prohibition was finally repealed in 1933, breweries like Yoerg were able to resume production of bona fide beer.

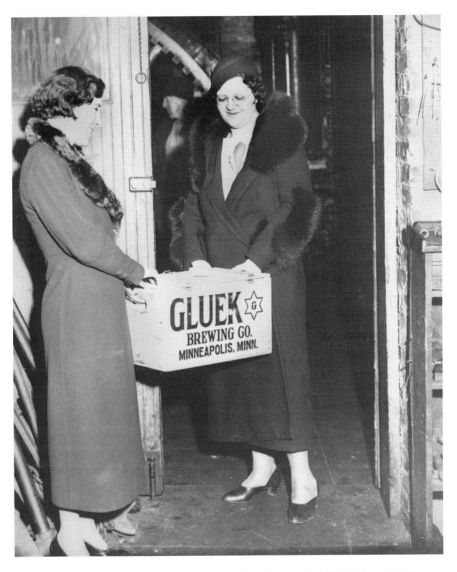

Two women carrying a case of Gluek beer following the repeal of Prohibition in 1933. *Minnesota Historical Society.*

For example, Minneapolis Brewing Company began rolling out barrels of draught beer in October and, on December 14, bottled beer, promoting its Grain Belt label as "The Friendly Beer with the Friendly Flavor."

Grain Belt's history website reported, "Post-Prohibition demand was so high that delivery trucks stayed out 12 to 15 hours a day just to keep up.

Minneapolis Brewing sold 30,000 barrels in June 1934 alone, generating profits in excess of $19,000 for the month. At the time, over 600 workers were employed in the Minneapolis plant."

Unfortunately, the post-Prohibition beer boom did not last forever. In the decades ahead, the beer brewing industry would face consolidation and downsizing.

ST. PAUL'S BIG BREWERS

For most of the twentieth century, St. Paul was home to two of the nation's mightiest brewing companies.

On the city's East Side near Swede Hollow was the Theodore Hamm Brewing Company, home to "The Land of Sky Blue Waters."

And across town, on West Seventh Street, the massive Schmidt Brewery held court as "The Brew That Grew with the Great Northwest." The fact that St. Paul was home to the two such giants was a testament to its economic vitality.

HAMM'S AND "THE LAND OF SKY BLUE WATERS"

In 1865, German immigrant Theodore Hamm took over the small Pittsburgh Brewery overlooking Swede Hollow (St. Paul's lower Phalen Creek area) when its prior owner, Andrew Keller, defaulted.[42] Prior to taking over the brewery, Hamm and his wife, Louisa Bucholtz, owned and operated a boardinghouse-saloon in the area of Fort Road and Sherman.

Although a neophyte to brewing (he originally was a butcher), Hamm exhibited a Midas touch with his operation, and his production steadily grew. By 1878, Hamm had turned Keller's old five-hundred-barrel-a-year plant into a five-thousand-barrel-a-year operation. Four years later, the brewery's annual output was twenty-six thousand barrels. With Hamm's growth came larger quarters for the brewery as it grew from one lot in 1860

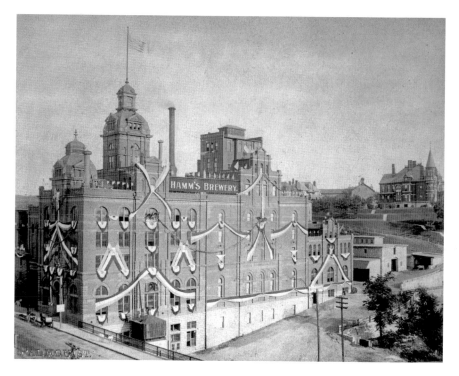

The Hamm's brewery was a key landmark on St. Paul's east side, pictured here circa 1900. *Minnesota Historical Society.*

to four acres with several buildings by 1885. By the 1880s, Hamm's was reportedly the second-largest brewery in Minnesota.

Theodore Hamm would lead the Hamm's brewery until his death in 1903. Then, his son, William, succeeded him, running the family business as company president for some twenty years until his death in 1931.

Next came William Hamm Jr., who played a significant role in carrying on the family's tradition. He spent more than forty years on the brewery's executive board, served as vice-president from 1915 to 1931 and was president from 1932 to 1960.

Despite his successful corporate leadership, William Jr. probably is best remembered as one of the victims of the famous Barker-Karpis gang's 1933–34 dual kidnapping schemes.

St. Paul historian Gary Brueggeman noted,

> *On June 15, 1933, gang members kidnapped William Jr. outside his father's former residence at 671 Cable street (now Greenbrier) and held him*

for $100,000 ransom. The ransom was paid and William was released unharmed.

A few months later, on January 7, 1934, the gang struck again, this time kidnapping Adolf Bremer's son, Edward, successfully ransoming him for $200,000. (Bremer was associated with the Schmidt brewery.) Thus, two of the most notorious kidnappings in American history were perpetuated on the families of two of St. Paul's leading brewers.

Another key figure in Hamm's growing success from the 1930s through to the early 1960s was William C. Figge, who became the company's president in the 1950s. William Hamm Jr. stayed on board as company chairman. Under Figge's watch, the Hamm's brand became a national powerhouse rising to become the fifth largest U.S. brewery with breweries in St. Paul, Minnesota; Los Angeles, California; San Francisco, California; Baltimore, Maryland; and Houston, Texas.

Between 1946 and 1954, Hamm's implemented a $16 million expansion. In 1952, as written in *Here's How at Hamm's*, a company fact sheet: brewery officials said the plant covered twenty acres, employed 1,300 workers and reached 1.5 million barrels in annual production. Five years later, the brewery's production had more than doubled to 3.3 million barrels annually.

The Hamm's Bear

In *The Paws of Refreshment*, Moira Harris describes in detail the history of Hamm's advertising. In 1945, the Campbell-Mithun agency won the Hamm's account. In looking for a way to turn Hamm's into a national brand, the ad agency came up with two notable slogans: "America's most refreshing beer," and "From the Land of Sky Blue Waters." Eventually, these two ideas were merged in the 1950s to read "Refreshing as the Land of Sky Blue Waters."

The slogan was the backdrop to scenic photographs depicting a northern lake with trees. Minnesota resort owners soon aided the campaign by posting calendar signs of the Hamm's advertising on their premises. The State of Minnesota so greatly appreciated the added publicity that it named a lake, Lake Figge, after brewery president William Figge.

Hamm's also won two consecutive awards for being the top float in the Tournament of Roses parade. Hamm's continued to participate in the St. Paul Winter Carnival.

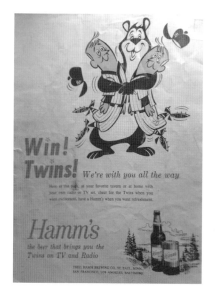

Win!
Twins! We're with you all the way

Hamm's
the beer that brings you the
Twins on TV and Radio

The iconic Hamm's bear was the key marketing symbol for the Hamm's Brewing Company. This advertisement appeared on the back cover of a 1960s Minnesota Twins' yearbook, which the author owned as a grade-school boy. *Author's collection.*

But Hamm's most famous advertising campaign featured a lovable, goofy cartoon bear, believed to be the creation of Cleo Hovel at the Campbell-Mithun advertising agency in Minneapolis. In surveys conducted by *Television* and *Television Age* magazines in 1957, the bear commercial was rated as the best liked.[43]

Often portrayed in TV ads as tipping over canoes or tripping over his own feet, the Hamm's Bear was named by *Advertising Age* in 1999 as a key emblem of the seventy-fifth best ad campaign of the twentieth century: "Hamm's beer: 'From the Land of Sky Blue Waters.'"

When Hamm's celebrated its 100th anniversary, the Hamm family decided to sell the brewery in 1965 and leave the ever-growing competitive brewing industry to focus on other business ventures.

In 1975, the 113-year-old Hamm's Brewing Company, the last of the locally owned breweries, was sold to the Olympia Brewing Corporation of Washington State. Olympia controlled the plant and the Hamm's brands until it sold ownership to Stroh's in the mid-1980s. Stroh's operated the plant for about another decade before closing in 1997. Hamm's rolled out its last beer in 1997.

SCHMIDT AND "THE BREW THAT GREW WITH THE GREAT NORTHWEST"

The Schmidt Company dates back to 1855 when its forerunner was known as the Cave Brewery. The brewery on West Seventh Street later took on the name of Jacob Schmidt in the early 1900s when he and his family assumed its operations.

Ironically, Jacob Schmidt got his start in the beer industry as a brew master for Theodore Hamm and was a good friend of the Hamm family,

staying in their employ until the early 1880s. But Schmidt left Hamm's after an argument ensued over how Theodore Hamm's wife, Louise Hamm, had disciplined Schmidt's daughter Marie.[44]

In creating his new brewery, Schmidt transferred partial ownership to a new corporation that was headed by his son-in-law Adolph Bremer and Adolph's brother Otto. This corporation would later become Bremer Bank.

After Jacob Schmidt's death in 1911, the Bremers took control of the company and kept the brewery growing.[45] Even when Prohibition hurt U.S. brewers, the Schmidt plant weathered that storm by producing nonalcoholic beverages from 1920 to 1933. As a result, Schmidt was well positioned to resume production of real beer after the end of Prohibition.

By 1936, Schmidt's was the seventh-largest U.S. brewery. Benefitting from a long-standing friendship between the Bremers and Franklin D. Roosevelt, Schmidt's gained a federal government contract to supply beer to U.S. troops during World War II.[46]

In 1954, rising competition prompted the Bremers to exit the brewing industry, and they sold the brewery to Detroit-based brewer Pfeiffer Brewing Company. Pfeiffer's acquisition of Schmidt came during a decade of industry consolidation when nearly two hundred breweries in the United States were either closed or sold to larger companies from 1947 to 1958.[47]

Pfeiffer's strategy of buying smaller regional brands was aimed at building its total sales. But in hindsight, that game plan only saddled Pfeiffer with many poorly maintained, inefficient plants with shaky sales. For Pfeiffer, it

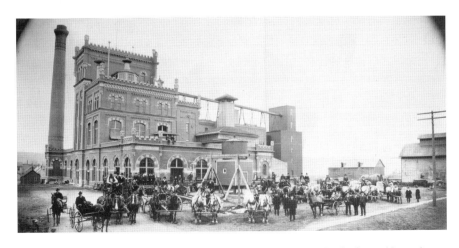

The Schmidt brewery was a key landmark on the west side of St. Paul, pictured here circa 1905. *Minnesota Historical Society.*

was a slow decline. In 1972, the company filed for dissolution, then sold all of its assets to G. Heileman of La Crosse, Wisconsin.[48]

For a time, the Schmidt plant fared well under the ownership of Heileman's, which rose to become the fourth-largest brewing company in America. The St. Paul brewery ran at near capacity, proving as efficient as its owner's La Crosse plant. Bottles and cans of Blatz, Schmidt and Hauensten rolled off the assembly line along with Heileman's flagship brand, Old Style.[49]

Still, without a national brand, Heileman's was vulnerable to other competitors. In 1987, Australian corporate raider Alan Bond bought out Heileman's. Subsequently, Heileman's was among the collateral casualties of Bond's junk bond empire that crashed, resulting in the largest financial collapse in Australian history. Three years later, in 1990, Heileman's ceased production at the old Schmidt plant, the first cessation of brewing there since 1855.[50]

SEASONAL JOB, LIFETIME CAREER

Throughout the twentieth century, for thousands of St. Paul East Side residents, a job at the Hamm's or Schmidt breweries wasn't just a paycheck. It was the foundation to enjoying the American Dream and a unifying tool for creating community. It was not uncommon for the two big breweries to have families with third- and even fourth-generation workers in the ranks.

Mike Goldman of St. Paul was among those who enjoyed the stability of brewery employment, working at the Schmidt plant before it closed. He later landed a similar job at the former Hamm's plant when it came under the ownership of the Stroh's Brewing Company.

Goldman's first job at Schmidt was serendipitous. In the spring of 1973, Goldman was a student at the University of Minnesota in the Twin Cities when he heard that Schmidt was hiring seasonal workers for the summer. "A friend had worked there (Schmidt) the previous summer," Goldman recalled, noting he applied for a summer job and landed a position on the brewery's third shift. At the end of the summer, Schmidt sought to expand its permanent workforce to meet its growing business.

"They (the brewery) offered a couple dozen of us (the chance) to be permanent workers, and I jumped on it," Goldman told *Twin Cities Beer*.

"Once you were offered a permanent job, you were pretty much set. That is where you stayed."

For the next seventeen years, Goldman worked at the Schmidt plant, first as a laborer stapling and binding cases for the beer bottles and later as a forklift driver:

> *Over the years, I did almost all the different jobs in the bottle house. Eventually, I was trained into more complex jobs. That included working in the government cellar, keeping track of the statistical information as it pertained to the large refrigerated storage tanks, pump through the filter that ran to the brewhouse. I was also a forklift driver and palletized driver and part of the clean-up crew for the floors and machines. The duties included switching the beer brands on the fly once a week, doing the sanitizing operations through the beer lines as the tanks needed to be cleaned up.*

Back in 1973, Schmidt employees made good money, with starting wages at $8.00 to $9.50 an hour, Goldman said. Through the years, the brewery workers received regular raises.

Goldman remembered working at the brewery was also a "very collegial environment. People developed a sense of friendship and long-term tenure. They are guys who grew up in the neighborhood, sons, fathers, grandfathers, and great grandchildren."

While working at the Schmidt brewery, Goldman met fellow employee Bob Dickhaus, who became "my best friend. I was best man at his wedding and godfather to his son. I think the same kind of camaraderie existed at the Hamm's Brewery. It was community based. It was desirable to get jobs at the brewery if you lived in that East Side neighborhood."

During the good years, Goldman recalled a few summers were so busy that "I didn't have one day off." When there was a cornucopia of overtime, you would bank that money to help you get through the slow periods, he said.

Meanwhile, the brewery was a testament to how various groups of employees could meld their talents together to support a well-running plant. Several unions represented different groups of employees; the biggest labor group was bottle house workers. There were also unions representing electricians, masons, pipefitters, maintenance workers and truck drivers.

"It was an evolved work arrangement," Goldman said.

While Schmidt and its brands held their own in the beer market, the fortunes of the St. Paul plant were adversely affected by the Australian

corporate raider who had bought Schmidt's owner, G. Heileman Brewing of LaCrosse, Wisconsin. The corporate junk bond raider Alan Bond bought Heileman in 1987, two weeks before the huge stock market tumble. Goldman said Bond bought Heileman for far in excess of its true value, a move that put Bond in a deep financial bind after the stock market plummeted.

The trickle-down impact on Schmidt is that because of Heileman's tight finances, it was unable to make any major marketing investment that would have helped stabilize Schmidt's situation. Goldman said, "The Bond group had a huge amount of debt and no way to pay it back. At that time, Miller and Budweiser were taking significant aim at the regional players who were nipping at the edges. This put us at a disadvantage for making any major marketing investment that would have stabilized the situation."

In 1990, the Schmidt plant closed, laying off about 215 employees, a significant number who were third- and fourth-generation brewery workers.

Following Schmidt's closing, the union held a holiday party for the laid-off workers, an event that was funded from dollars set aside in a trust account. "A lot of people thought that working at the brewery was the best job that they had ever had," Goldman recalled.

Following Schmidt's closing, "We mobilized the community to see if we could recruit a purchaser to keep it open," Goldman said. "We also tried securing a state grant to help keep the plant open as it was still useable."

But G. Heileman Brewing, Schmidt's owner, had no interest in selling the brewery, as it became apparent it didn't want a competitor in its own backyard. (For a time, the rival brands of G. Heileman Brewing and Schmidt were being produced side by side in the Schmidt plant.)

In 1992, after a St. Paul feasibility report, the Schmidt brewery reopened as Landmark Brewing under the direction of Bruce Hendry, a St. Paul businessman and lead investor.

Looking back on the successive efforts to revive the Schmidt brewery, Goldman observed, "It was almost unheard of for a plant to close and then reopen."

Many former Schmidt workers went to work for Landmark Brewing, a benefit they reaped from successorship language in their union contracts with Schmidt. Of the 215 Schmidt employees who were laid off, fewer than half of them chose to go back to work when the plant reopened as Landmark Brewing, Goldman said. "Most other people had found other jobs and careers."

Landmark Brewing operated for a few years before it closed in 2002. It was followed by a short-lived ethanol plant.

SUCCESSORS TO HAMM'S AND SCHMIDT BREWERIES

When the Hamm family put the company on the corporate auction block in 1965, their move signaled the end of decades of brewery stability. Heublein first acquired Hamm's and, only six short years later, sold it to a group of Hamm's distributors in 1971. Those distributors, in turn, sold the old Hamm's company to Olympia Brewing in 1975.

Then more horse trading occurred in the 1980s. In 1983, Pabst bought Olympia along with Hamm's, then traded the St. Paul flagship brewery that year to the Stroh Brewing Company.

Stroh's tenure in St. Paul ran for fourteen years before it shut down the brewery in 1997. Stroh's closing ended a 137-year brewing tradition on the East Side.[51]

Another decade passed before the old Hamm's mega-site had signs of new life. While the brewery was shuttered, the Hamm's brand lives on under the ownership of MillerCoors.

Over at the Schmidt plant, a group of local investors reopened the brewery under the auspices of the Minnesota Brewing Company, which produced the Landmark and Pig's Eye flagship brands. The two labels represented the brewery as an iconic "landmark" in the St. Paul neighborhood and Pig's Eye as the name of the man believed to be the first settler in the St. Paul area.[52]

For a while, Minnesota Brewing Company did well, reviving the Grain Belt brand along with handling contract brewing from several smaller independent brewers. In the mid- and late 1990s, the brewery operated at a capacity of almost 1.2 million barrels per year. And the brewery rehired laid off employees who still needed work.

However, Minnesota Brewing's good fortunes did not last forever. The company got squeezed in the middle; it was too big to distribute only in the immediate area but not large enough to compete on a national level. Further, the old Schmidt plant's equipment had become outdated. And in some cases, its wholesale customers were financially shaky, either failing to pay for beer orders or just plain going out of business themselves. All of these factors conspired in concert, forcing the permanent closing of the St. Paul brewery in 2002. The last kegs that rolled out of the location were filled with Grain Belt and Pig's Eye brew.[53]

The next major industrial use of the Schmidt plant had a four-year run in the early 2000s. Gopher State Ethanol Company began production of industrial grade ethanol. But its startup annoyed neighboring residents

and businesses that found the operation's noise and smell offensive. In fact, neighborhood groups petitioned to have the ethanol plant cease production. In the wake of this community pressure, Gopher State Ethanol closed its doors in 2004.[54]

BREWERY REDEVELOPMENTS

In the last decade, redevelopment has sprung from the fermenting ashes of the Hamm's and Schmidt breweries with both sites yielding an interesting mix of new businesses and reuses.

But redevelopment did not come easily and was a challenge for developers. In 2013, St. Paul's mayor Chris Coleman expressed concerns about the two brewery sites. "For years, we wondered, how can we ever do anything with them," Coleman said in an interview with *MinnPost*. "But now we're finally finding some great new uses."

SCHMIDT REUSE

At the Schmidt site, the Dominium Company erected an apartment/artist studio complex in 2012, building 247 live/work rental lofts on the brewery's sixteen-acre site. Called the Schmidt Artist Lofts, the estimated $120 million project was a challenge for Dominium to build because the brewery's historic designation required that developers maintain the exterior look of the building.

A lot of public subsidies went into the housing project, including about $40 million in preservation grants along with some low-income housing monies and county and city clean-up funds. Overall, the goal was to maintain the brewery's exterior appearance as it existed in the early 1900s.[55]

There were signs that the old Schmidt brewery was not forgotten. The huge outdoor Schmidt sign that glowed red in the night over St. Paul was relit on June 15, 2014, after a hiatus of more than twenty years.

Matt Hill, vice chairman of the St. Paul Historic Preservation Commission, told the *Pioneer Press*, "The relighting of the Schmidt Brewery sign is emblematic of the economic redevelopment we are seeing take place in West Seventh and across St. Paul through the reuse of our historic resources."

(The old Schmidt sign was taken down and replaced with an unpretentious, non-flashing LANDMARK sign in the 1990s.)

Meanwhile, there are plans for Schmidt's former Rathskeller building to house a German-style beer hall slated to begin this year (2018). In 2017, the St. Paul City Council approved selling the building for $1 to developer Craig Cohen contingent on him also finding financing for the redevelopment project.[56] Cohen also has plans for rehabbing the neighboring Keg House into a row of indoor and outdoor restaurants that will be known as the Keg and Case Market. Cohen said that project is fully pre-leased, and he expects the marketplace to open this year.

Hamm's Reuse

The rebirth of the sprawling Hamm's brewery site has taken several years. Before any new development could occur, millions of dollars were spent in cleaning up the heavy industrial site. Now, new businesses have gradually gained momentum in the last several years. Here's what's happening, with some of it occurring with the assistance of private developer Howard Gelb:

The TWIN CITIES TRAPEZE CENTER, founded in August 2012, offers flying trapeze lessons to people of all ages and abilities. The old brewery warehouse, with its forty-foot high ceilings, is ideal for the high-flying business to hang its trapeze rigs.

On its website, the Center proclaims, "Gone are the days when you had to be born into a circus family to experience the joy of 'flying through the air with the greatest of ease.' Now you can take a class at Twin Cities Trapeze Center and feel the thrill of the circus without running away."

In June 2004, HEALTH SYSTEMS COOPERATIVE LAUNDRIES completed renovation on a state-of-the-art facility at the old Stroh's/Hamm's brewery site, allowing it to process thirty-eight million pounds of laundry annually. "The investment in the facility and new sorting/washing/drying technology has allowed HSCL to realize the full potential in serving customers in a more cost-effective manner along with expanding the menu of services offered to their customers," according to its website. The cooperative employs about 250 workers and occupies a sixty-five-thousand-square-foot pallet building.

ELEVEN WELLS opened its distillery in 2016. With eleven wells on the former Hamm's brewery site, the Eleven Wells company is using the eleventh well as the water source for its spirits. Partners Lee Egbert and

Bob McManus located the distillery's production in the old Blacksmith and Millwright Shop buildings on the vast Hamm's site. One of Eleven Wells' spirits is moonshine converted from what was called Minnesota 13, an open-pollinated corn developed by the University of Minnesota in the 1880s to give farmers a quicker-growing season. Locals brewed this moonshine in defiance of temperance efforts.

URBAN ORGANICS, an aquaponics fish and produce farm, has been operating from the site of the old Hamm's plant since 2014, making use of water from the old brewery well. From its pilot nine-thousand-square-foot facility, the company has been so successful that it went across town and in the spring of 2017 opened a mammoth eighty-seven-thousand-square-foot indoor farm in the former Schmidt Brewery.

However, perhaps the most interesting of the new businesses to rise out of the ashes of the old giant brewery is FLAT EARTH BREWING, a craft beer operator that typifies the booming breed of new microbreweries.

Founded in 2007 out of a small site near the Pearson's Candy Company on West Seventh Street in St. Paul, Flat Earth Brewing relocated to the former Hamm's brewery in 2014 to accommodate its expanding business. Its first day of business there was on April 22, Earth Day.

In moving into the Hamm's Brewery's former buildings No. 7 and No. 8, Flat Earth doubled its annual production to about three thousand barrels. And in relocating, Flat Earth has gained nearly eightfold space, from six thousand square feet to forty-six thousand square feet.

Among Flat Earth Brewing's most popular hand-crafted beers are Angry Planet Pale Ale and Cygnus X-1 Porter. Its assortment of seasonal specials includes Black Helicopter Coffee Stout, Red Cape Irish Red Ale and the Mummy Train Pumpkin Ale. The addition of Flat Earth Brewing has been just another link into rebuilding the once mighty Hamm's site.

"We want to grow and rehab this St. Paul area," said Franco Claseman, Flat Earth director of operations. "We want to fix it [the Hamm's Brewery site] up so the history wouldn't get lost."

RESURRECTION TIME

T wo of the most prominent names in Twin Cities brewing circles, indeed in all of Minnesota, have resurfaced.

Less than a mile from its original site in St. Paul that made it Minnesota's first brewery, Yoerg Brewing Company is back after a sixty-four-year hiatus. Meanwhile, across the river in Minneapolis, Gluek's beer has returned after a seven-year absence that began in 2010.

Bringing Back Yoerg

For years, Thomas Keim dreamed of resurrecting the Yoerg Brewing Company. As a ten-year-old boy in the 1960s, Keim discovered some Yoerg returnable bottles in a crusty box of collectibles in the basement of his father's liquor store and was smitten by their color and label graphics. Back then, the Yoerg's brewery was already more than a decade past its 1952 shuttering.

Note: The closing of the Yoerg brewery was precipitated by a steady decline in the company's business that began during World War II when barley was needed to feed American troops and brewers were forced to turn to corn syrup as a substitute. After the war, U.S. brewers continued using corn syrup over barley in the brewing process, Keim said. But Yoerg refused to adopt that change, insisting that corn syrup was a cheap alternative to the more expensive barley in the beer brewing process.

The taproom for the newly revived Yoerg Brewing is located at 427 Wabasha Avenue in St. Paul. *Thomas Keim.*

Anyway, seeing those empty Yoerg bottles would forever remain embedded in Keim's mind.

Yoerg Brewing Company, you will recall, was founded by German immigrant Anthony Yoerg, who built and opened the brewery in St. Paul in 1848, the year before Minnesota became a territory. Yoerg was just thirty-two when he started the brewery, and he went on to build one of the most successful breweries in Minnesota history, in Brueggeman's estimation.

Despite its closure, the Yoerg Brewery remained a legend. "The beer has a cult following," Keim explained, noting Yoerg's key demographic today is largely baby boomers. "People reaching out to us are people in their 40s, 50s, 60s and 70s."[57]

"When the Internet came along, the Yoerg bottle became one of the most collectible beer bottles in the country," Keim continued, noting that some of the brewery's old glasses sell for as much as $700 apiece, while Yoerg ashtrays can command $150 to $200.

By the time Keim grew up and began his career in the liquor industry, he was on a vigilant watch to someday acquire rights to the Yoerg brand. That time finally arrived in 2012, when Carole Minogue, Keim's business partner and girlfriend, noticed that trademark rights to the Yoerg brand had lapsed. In 2015, with the help of a Florida trademark attorney, the couple secured trademark rights to Yoerg Brewing within six months of pursuing them, Keim said.

The couple's acquisition of Yoerg Brewing's intellectual property includes access to the Yoerg beer recipes. "We took two years to perfect the recipe in making a steam lager with special yeast," Keim said. "The

malt [we use] is heavily roasted to bring out the dark color and its roasty, toasty taste."

Currently, the brewery's portfolio of old-fashioned steam lagers includes Yoerg Bock, Yoerg Strong Beer and Yoerg Picnic Beer. The company expected to release the original Bock label beer of the 1930s before the start of summer 2018.

Through test batches, Keim and his team achieved a historically influenced recipe that they believe fills a niche in the current lager market. The yeast they're using is expensive and has to be cultivated immediately, making it a challenging brew cycle that demands a top brew.

After failing to find a local brewer to produce Yoerg beer, Keim contracted for those services from Octopi Brewing of Waunakee, Wisconsin. "We brew our beer in 100-barrel batches," he said. "We look to produce 50 to 75 barrels a month."

Meanwhile, Yoerg Brewing's new home for its taproom and nanobrewery is 427 South Wabasha Street, on St. Paul's West Side, right across the street from the Wabasha Brewing Company and less than a mile away from Yoerg's original brewery.

The new Yoerg taproom and nanobrewery features on-site brewing with a three-barrel capacity. "We will be the first brewpub in the nation that will be doing extensive lists of wines," added Keim, who once ran a chain of wine bars in California.

As this book went to press, the former Wabasha Bar was being restored to its former glory for Yoerg Brewing. Keim hopes to hold the grand opening of the bar between August 15 and September 1, 2018. Part of the renovation of the art deco building has included restoring a series of wall murals that

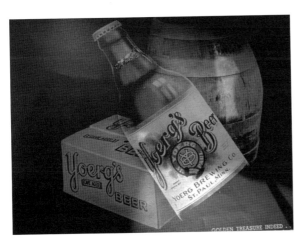

Yoerg's Beer. *Minnesota Historical Society.*

were painted in 1933 right after the end of Prohibition. Keim also had plans to display lots of Yoerg memorabilia at the taproom.

"We want to preserve the history of the building and also tell the story of the Yoerg family'" Keim told the *Pioneer Press*. "They [the Yoerg family] were really involved in the community and deserve something special."

Built in 1910 by the Schmidt Brewing Company as a "tied house" (meaning the bar could only serve Schmidt beer), the Wabasha Bar closed sometime in the late 1970s and saw a couple more name changes before being shut down for good in the late '80s, according to the Yoerg website.

Keim envisions the Yoerg of today as a continuation instead of a remake. "We want to act like the brewery never closed and never aged," he told *Twin Cities Beer*. The red-and-white artwork, circa roughly 1910, is here to stay.

BRINGING BACK GLUEK

Another historic Twin Cities' brewing warhorse has also made a comeback: Gluek's beer.

The classic Gluek's Minnesota beer brand started in 1857 and had a 153-year run until its last owner, Cold Spring Brewing Company, retired it in 2010 to focus its attention on brewing another beer. After a seven-year hiatus, in May 2017, Minnesota's former German-style beer brand made a comeback in the Twin Cities.

Linda Rae Holcomb, the new owner, announced, "Gluek Beer is back, and here to stay." Holcomb, whose family owns Gluek's Restaurant & Bar, acquired the beer brand from Cold Spring Brewing Company in July 2015.

"It was heartbreaking for me when I first heard the news that Gluek beer was going to be retired, many years ago," Holcomb, a "lifelong devotee of the Gluek brand," told *Twin Cities Beer*. "This news sparked a fire inside me, which led me on a long, passionate journey to acquire the brand.

"After the Gluek family initially sold to Heilemann in the 1970s, the brand was bought and sold over and over again," with little attention to the beer's quality, Holcomb contended. "Trying to put an average brew into the Gluek can, to try and sell it on the name alone and with no attention to quality. I truly believe that finally the Gluek brand is back in the hands of someone who really cares."

Gluek's beer is inspired by "old world tradition" and uses Munich malts and traditional Saaz hops, according to the company. Holcomb said she has

Linda Holcomb is the owner of the revived Gluek Brewing Company. *Gluek Brewing Company and Linda Holcomb.*

paid great "attention to detail to make sure that the beer is of top quality and a premium standard.

"I tracked down Ray Klimovitz, a German chemist and former brewmaster from back in the day, to write the recipe, based on what the Gluek family had

originally intended," Holcomb said, adding, "I was also able to locate Tom Jahnke, a designer from Wisconsin whose father had created all of the Gluek labels from the 40s through the 60s, to design the first label, consistent with those of the past. Gluek beer is back and here to stay."

Meanwhile, Holcomb has hired Denver-based Sleeping Giant Brewing Company to produce and package the Gluek beer and distribute it to bars, restaurants and liquor stores across southern Minnesota. Holcomb expected Sleeping Giant Brewing to produce about 2,500 barrels of Gluek beer in its first year back on the market.

In the relaunch, Gluek's beer is now available in sixteen-ounce cans in liquor stores and on tap at several restaurants, including Gluek's Restaurant & Bar, the Loon, Gigi's Cafe and Bread & Pickle.

In 1964, the Gluek family sold the brewery to a company in Wisconsin, and the Minneapolis brewery was eventually demolished. The brand returned in 1997 under Cold Spring Brewing Company in St. Cloud. Cold Spring made Gluek's for a while, but in 2010, it stopped producing the beer commercially.

Holcomb said her great-grandfather Charlie Fransen was the "right hand man" for the Gluek family during Prohibition. The Gluek family built Gluek's Restaurant in 1902 as a distribution outlet for their beer, but the restaurant closed during Prohibition. Fransen reopened the restaurant in the mid-1930s, and it has remained in that family's ownership for four generations, said Holcomb, who previously worked as an accountant for Gluek's restaurant.

Today, the Gluek Beer brand is a separate company and not related to the restaurant, although they both share the same namesake.

THE MIGHTY CRAFT BEER TWINS

S lammed by the effects of Prohibition in the 1920s and early 1930s, the U.S. beer industry declined from about seventy breweries after World War II down to only forty in the early 1970s. Of that number, fewer than five of those breweries were in Minnesota.

But two Twin Cities breweries would soon signal a new era for Minnesota.

The first one, St. Paul–based Summit Brewing Company, would introduce locally brewed craft beer. The second, Minneapolis-based Surly Brewing Company, would ultimately help usher in a barrage of microbreweries that would sweep this metro region.

While a few giant breweries did a lot with their large facilities (most noticeably, Budweiser, Miller and Coors dominated the national beer market), Mark Stutrud, a St. Paul transplant from North Dakota, saw the industry consolidation as a business opportunity for smaller brewers to carve out new niches.

Stutrud watched this brewery trend for some time, and it particularly caught his attention after the federal government legalized homebrewing in 1978 and Minnesota followed up with its own specific statute in 1980. Also, about that time, imported beer started gaining popularity with beers coming in from Canada, Mexico, England and Scotland. As a result, the consciousness of beer changed. Michael Jackson, British purveyor and chronicler of craft beer, elevated it to a new level.[58]

"Breweries dealing in classic lager styles had good skill and stability and control in massing producing. The big breweries focus on a few kinds of

beer but do them well," said Stutrud, originally a home craft brewer. "That created an opportunity for little brewers to create new niches."[59]

Dreaming of becoming a commercial craft brewer, Stutrud spent two years (1982–84) researching the beer industry and reading up on the experiences of the pioneers who had recently launched their own microbreweries. Among his stops were to Redhook Ale Brewery's original brewhouse, located in a Seattle transmission shop, and an apprenticeship under Bill Newman, owner of the defunct William S. Newman Brewing Company in New York.

In 1984, Stutrud started Summit Brewery, leaving his chemical dependency counselor job at St. Mary's Hospital in North Dakota. Stutrud also passed up an opportunity to go to medical school in favor of pursuing a career in brewing, a move he jokingly explained "probably was due to my Scandinavian DNA." He admitted, "In the beginning it [starting Summit] was a crazy idea." It was also daunting.

"We found out how intimidating it was to be competing with the big guys. The big guys know how to make beer. It is only the value judgment of people who say that Budweiser isn't worth drinking. There is a certain elitism in the industry. We don't have arrogance. We have humility that we know what it is."

Despite some trepidation in striking out on the craft beer trail, Stutrud was convinced he had done all he could to give himself a chance to succeed in his new venture. He got Summit Brewing going with the help of business counseling advice from SCORE (Senior Corps of Retired Executives) and a comprehensive business plan that he put together over the first five months of 1984.

"If this [brewery] was to succeed, we needed to raise $600,000 to $750,000 from initial investors plus an SBA [Small Business Administration] loan," he said. "I didn't come from a business family or one that was well heeled."

SUMMIT BREWING DEBUTS IN 1986

"It was a good four years, from research and planning, to when we sold our first keg of beer in 1986. In so doing, Summit Brewing became not only the Twin Cities', but Minnesota's first microbrewery....Microbrewery was not in many people's vocabulary [back then]," Stutrud recalled. "In the

Beer brewing tanks at Summit Brewing Company. *Summit Brewing.*

entire Twin Cities, there was no active presence. To say that we were pioneers [in the Twin Cities craft beer industry] is not an exaggeration."

Summit's first beer was a distinctive British ale, Extra Pale Ale, then came its Great Northern Porter. Stutrud pointed out that these were good choices for the first beers because the turnaround time to produce ale is faster than lager beer. Also, ales have a distinctive taste, different from the typical American lager.

Summit's initial annual brewing capacity of three thousand barrels was made possible from a small brewhouse that the company bought and had shipped from Germany to the Twin Cities. "Our plant's fermentation vessel was built here in Minnesota by a stainless steel company that specializes in industrial food equipment," Stutrud said. "A good $400,000 went into our building and equipment." Today there are more than one hundred manufacturers of brewery equipment, up from the ten of just a few years ago.

In those startup years, Stutrud struggled to find sources for the raw materials needed to brew and produce beer. For example, Idaho, Washington and British Columbia were only among the handful of places where local breweries could import various varieties of hops. "Now we get hops from all around the world," he said.

Stutrud also noted that during Summit Brewing's startup, there was only one company bagging its malt, Briess Malt & Ingredients Company in Wisconsin. "Now, today, you can get malting bagged from around the world. Before you were limited in the equipment you could get and raw material, and no beer wholesaler would touch you with a 10-foot pole. So, we did our own [beer] distribution for the first 10 months."

Initially, Summit Brewing's growth came in fits and spurts. In its second year, the company introduced bottled beer. "By the end of 1988, we had four part-time employees on the bottling line and had 3,000-barrel capacity and sold 1,500 barrels," Stutrud reminisced.

Left: Extra Pale Ale is one of Summit Brewing's most popular beers. *Summit Brewing.*

Below: Summit Brewing headquarters. *Summit Brewing.*

In the early 1990s, Summit's business began to take off, with sales growing at double-digit annual rate. In 1992, the company leased 15,000 square feet of space in a second building, doubling the original 7,500 square feet of its first building. That expansion gave Summit a maximum brewing capacity of thirty-four thousand barrels per year.

Summit Brewing's production and sales continued booming. But with no further room to expand at the former truck parts building that served as its maiden location on University Avenue in St. Paul, in the mid-1990s, the company began looking for a new location for operations. After first considering the old Grain Belt Brewery building in Minneapolis for its new home and then land near its existing St. Paul facility, Summit Brewing chose a four-acre parcel at St. Paul's Crosby Lake Business Park, once home to the Texaco tank farm that had been reclaimed for new business development.

Summit completed its land purchase with the St. Paul Port Authority in 1997, pledging to bring at least several strong-paying jobs to the site. By the end of 1998, Summit Brewing had grown to ten full-time employees and fifteen part-time workers. Its annual brewing capacity now was sixty thousand barrels.

Perhaps most astounding, Summit Brewing was the only operating brewery in the Twin Cities in the late 1990s and into the early 2000s.

By the close of 2013, Summit Brewing's facilities spanned 106,000 square feet. In 2012, the company added a fermentation storage tank, boosting its annual brewing capacity to more than 120,000 barrels, following up within the next two years by building a new addition to the brewery. That included a new canning line that is part of a $7 million project boosting annual production capacity to 240,000 barrels. "We have gone through an ambitious expansion in doubling our capacity."

Today, Summit Brewing has about one hundred full-time employees and a dozen part-time workers. The brewery's workforce has grown in production as well as sales, marketing, human resources and quality control. From its humble beginnings as a microbrewery, Summit Brewing has grown into a regional player, distributing its beers in at least fifteen states.

SUMMIT SUMMARY

Reflecting on Summit Brewing's ascendancy since its startup, Stutrud said, "My original business plan was for a 20,000 square-foot plant with maybe

25 employees and a predictable lifestyle. Back then, things were in their infancy. Now, it's hard to know how large the market might be. But we are in it for the long haul."

Getting Surly

While Summit Brewing was gathering momentum, across the river in Minneapolis, the seeds for Minnesota's next big craft brewery were being planted. This story begins in 1994 when Omar Ansari, son of a Pakistani father and German mother, got a homebrewing kit as a gift.[60]

Ansari's first swing at brewing, an Irish Red Ale, flopped, and after the failed experiment, the homebrewing kit went back into his closet, not destined to resurface until a few years later.

In time, Ansari's fondness for craft beer prevailed, and he gave the homebrewing kit another shot. This time, his results were much better, and he was hooked on homebrewing, according to the Surly website.

Ansari continued homebrewing for several years and also visited craft beer destinations across the nation. Soon, Ansari was regularly brewing, even after he got married and took over the industrial abrasives factory business that his parents founded and had run for some twenty years.

In 2002, Ansari "and his wife, Becca, had their first child, Max. Omar brewed an EPA with the birth announcement and a picture of the new baby on the label. He figured that would get a little more attention from his friends than the usual postcard. And it did. His friends and family said, 'Hey, congrats on the baby and all, but that beer was really great.'"[61] Those encouraging words spurred Ansari to pursue all-grain brewing from his garage.

By this time, Ansari wondered if the Twin Cities would ever become a national hot spot for craft beer, developing its own community and culture as had occurred in Portland, Oregon, and along the "American Beer Belt."

Then one day, in 2004, Ansari was inspired while paging through a homebrewing catalogue and saw an ad for a three-barrel brewing system: "Maybe I should open my own brewery." The idea had definite appeal, especially since his family's abrasives company was struggling, and he really wasn't passionate about the business. After analyzing the pros and cons of making such a business move, Ansari decided the positives outweighed the negatives.

With the blessing of his wife, Becca, mother, Dorit, and father, Nick, Ansari started assembling his plans to launch a microbrewery, which he envisioned running from the unused space within the confines of his family's abrasives factory.

The Surly website recounts the rest of the story:[62]

To really learn the craft beer trade, Omar took programs through the American Brewers Guild, then served as an apprentice at New Holland Brewing in Michigan.

At the spring 2004 Craft Brewers Conference in San Diego, Omar met Todd Haug, a heavy metal guitarist–turned–head brewer at Rock Bottom Brewery in Minneapolis. The two men instantly connected when they discovered they had gone to the same junior high school in Golden Valley. From that chance meeting, Haug invited Ansari to come to his brewery a couple days a week to learn the brewing trade.

Within a few weeks, Ansari and Haug teamed up to start their own brewery, with Todd designated as head brewer. In 2005, the two men retrofitted the abrasives factory in Brooklyn Park to accommodate a microbrewery, including putting in its plumbing and drainage and moving in and setting up the brewing equipment. Surly Brewing's first batch of beer came two days before New Year's Day 2006.

Initially, Ansari and Haug found that promoting Surly's first beer, a hoppy IPA called Furious, was a bit of a hard sell. Some bar owners spit out the beer after just one sip, and plenty of people were skeptical about their venture.

But Surly's beer soon grew on people. The company sold its first kegs of beer in February, and quickly, a growing number of bars, liquor stores and restaurants were carrying Surly beers. Additionally, Surly Brewing was gaining favor at brand parties and special events that the company was throwing, such as its annual SurlyFest. In an effort to keep up with the growing demand, Surly's owners added more brewing equipment, tanks and staff at its Brooklyn Park location. The time was rapidly approaching when Surly needed to build a new brewery to meet rising consumer demand.

By 2011, Surly Brewing had exhausted its production capacity at its Brooklyn Center brewery and was still not keeping up with consumer demands. Ansari and Haug knew it was time to build a new brewery. But what they envisioned was not any ordinary facility.

CHARTING A NEW DESTINATION

Ansari and Haug wanted to build a brewery where Surly could serve its beers, making their plant a "destination brewery." Their inspiration for this idea came after one of their employees told them that, while on vacation, he visited an Austrian brewery where he had enjoyed such an on-premise experience. "We thought that's what we should do for our new brewery," Ansari and Haug said.

However, Ansari's and Haug's plans faced just one problem: A Prohibition-era Minnesota state law only allowed very tiny breweries the right to sell pints of their beer on their premises to consumers. The state law regulating the beer industry's three-tier system was designed to keep breweries, distributors and on-premise sales separate.

But that law bothered Ansari and Haug. They wondered why Minnesotans shouldn't be allowed to gather and socialize over a beer where it was being brewed?

In February 2011, at one of several parties celebrating the company's fifth anniversary, Surly Brewing folks announced they wanted to build a brewery where people could come in, see where the beer is made and then drink the beer. But to do that, Ansari and Haug said they needed help changing the state law.

Two determined state lawmakers, Representative Jenifer Loon and the late Senator Linda Scheid took on their cause, sponsoring and championing legislation to drop the brewery restriction clause, saying that move would benefit the state's craft beer industry.

Over the next four months, Ansari and Haug rallied "Surly Nation" via social media and a legislative telephone campaign to lobby state lawmakers to drop the restriction in the state law. "It was about more than us selling pints of our beer at our brewery, it was about making Minnesota a craft beer destination," Surly officials said.

Their campaign for changing the law, however, was by no means a slam dunk. "The status quo made it clear that they were against our plan and would do all they could to stop it," Surly Brewing officials said, adding that they were told "'it'll be too difficult, we should just build a brewery in Wisconsin.' But we're Minnesotans. We cheer for the Vikings, not the Packers."

When Surly officials encountered pushback from some food and beverage lobbies, they asked their supporters to double down on calling legislators to support the bill. Ultimately, social media and phones exploded with activity.

Surly Brewing has grown to become one of the Twin Cities' largest craft brewing companies. *Surly Brewing.*

Surly's lobbying campaign prevailed. On May 24, 2011, Minnesota governor Mark Dayton signed the "Taproom Bill," also known as the "Surly Bill," into law. Under the new law, breweries producing fewer than 250,000 barrels annually were now allowed to sell pints on their brewery premises. Effectively, that meant microbrewers could open taprooms on their premises.

In a news story, *City Pages* said the 2011 state law change "destroyed the single biggest barrier to entry for new brewers—namely, distribution. The effect was like pulling the keystone out of a breaching dam." In the following five years, Minnesota saw a tripling of the number of operating breweries in the state.

Stutrud hailed the "Surly bill" as the pivotal event that spurred the influx of new breweries with taprooms. Taprooms give the microbrewers a natural profit center to generate sales and a way to distribute their beers without initially having to sustain large capital expenses.

Concluded Ansari, "Whether you like all the craft breweries or not, it's certainly a more vibrant, interesting scene than five years ago, and having all those breweries is part of it."[63]

Following its 2011 legislative victory, Surly Brewing moved on plans to build a $35 million brewery in Minneapolis's Prospect neighborhood. In October 2013, the company broke ground on the brewery, which boosted its annual production capacity to 100,000 barrels, almost a fourfold increase in production. Surly completed the project in December 2014.[64]

Surly's new brewery gives it ample room for increasing beer production. In 2015, the company produced about forty-eight thousand barrels. In 2016, its workforce numbered nearly three hundred employees.[65]

"In 2016, we experienced 23 percent growth, selling 76,550 barrels," a company spokeswoman reported. "The company grew to nearly 93,000 barrels produced in 2017."

Not content to rest on its laurels, Surly began installing new equipment in the spring of 2017 that gives it the flexibility to pack beer in either

twelve- or sixteen-ounce cans. That $1.1 million expenditure also prompted a change in packaging. In 2018, Surly has projected brewing about 115,000 barrels.

Now, more than a decade after the first keg was sold, Surly is one of the nation's fastest-growing and most forward-thinking craft breweries.

THE RISE OF THE MICROBREWERIES

Since 2011, the Twin Cities' cottage industry of microbreweries has been booming. Evan Sallee, president and CEO of Fair State Brewing Cooperative, said that what constitutes a craft beer or craft beer brewers is more about attitude than size. "It is how are you doing it [brewing]. And why."

Most have emerged as the brainchild of homebrewers tinkering with startups in their home basements or garages, then slowly expanding with the receptive support of family and friends. They generally endeavor to bring a high quality to their brewing and do so in smaller quantities. Their market focus is often geared to serving local communities. To launch fledgling microbreweries can require capital of upward of $1 million.

"It's truly an exciting time for craft beer drinkers in Minnesota," said Joe Giambruno, co-owner of Bad Weather Brewing Company in St. Paul. "We are seeing the craft beer scene grow and change very quickly, as Minnesota establishes itself as a destination for great local beer."

Zac Carpenter, Giambruno's co-founding partner at Bad Weather Brewing, agreed. "Minnesota is one of the most exciting places to be a beer lover…because we get to witness the birth of a great beer culture that will someday very soon rival the Portland and Denver scenes."

The event credited with spurring this microbrewery boom was the Minnesota legislature's passage in 2011 of the so-called "Surly bill," which enabled small brewers to operate taprooms from their production premises. That meant small brewers would be able to generate sales

without initially incurring the costly expense of undertaking distribution of their beers.

An Associated Press story said licensing records show two-thirds of Minnesota breweries have opened since 2010. "Every little town is having their own microbrewery," noted Robert Klick, owner of Wayzata BrewWorks in Wayzata. "It's a hip movement."

As of the spring of 2018, the Twin Cities had at least forty microbreweries, with plans for additional brewers coming on line. The following is a brief synopsis of existing breweries.

ABLE SEEDHOUSE + BREWERY

Logo for Able Seedhouse + Brewery.
Able Seedhouse + Brewery.

Able Seedhouse + Brewery, a microbrewery and malthouse, opened in 2016 at 121 Quincy Avenue North in the Logan Park neighborhood of Northeast Minneapolis.

The microbrewery's four owners—Casey Holley, Rick Carlsen, Matt Johnson and John Mowery—said they hope to "drive attention to our small grains grower and farmer network" along with highlighting grains of Minnesota and the Upper Midwest in brewing high-quality craft beers.

The foursome comes from a long line of manufacturers and are interested in connecting consumers to the source of what makes great beers.

Business hours: Mondays and Tuesdays closed for private events; Wednesdays and Thursdays 3:00 p.m.–11:00 p.m.; Fridays and Saturdays 12:00 p.m.–11:00 p.m.; Sundays 12:00 p.m.–8:00 p.m.

Fun fact: As of the end of March 2018, Able Seedhouse + Brewery was producing about three hundred barrels per month.

Website: ablebeer.com

BAD WEATHER BREWING COMPANY

Bad Weather Brewing debuted in 2013 from a shared production facility in Minnetonka, then opened a taproom two years later at 414 Seventh Street W in St. Paul.

Bad Weather Brewing Company logo. *Bad Weather Brewing Company.*

Bad Weather's co-founders Joe Giambruno and Zac Carpenter have a passion for the brewing process. "We like doing all varieties of beers and have fun both brewing traditional styles and bending the style guidelines," Giambruno said.

Giambruno graduated from the World Brewing Academy with an associate degree in brewing technology at Siebel Institute in 2011. He has a background in the biological sciences, including microbiology, genetics and zoology.

Meanwhile, Carpenter graduated from the American Brewer's Guild in July 2012 and worked at Lucid Brewing as part of the program. He is an award-winning homebrewer with a background in the worlds of commercial brewing and banking and finance.

Business hours: Monday through Thursday 3:00 p.m.–10:00 p.m.; Fridays 3:00 p.m.–12:00 a.m.; Saturdays 12:00 p.m.–12:00 a.m.; Sundays 12:00 p.m.–9:00 p.m.

Fun fact: The brewery has increased its production capacity four times in its first four years in business.

Specialty brews: Bad Weather's signature beer is a red IPA called Windvane. Available all year long, Windvane is hoppy, infused with pine, citrus and resinous flavors.

Website: badweatherbrewery.com

BADGER HILL BREWING COMPANY

Badger Hill Brewing Company began business in July 2012 in a Minnetonka facility that it shared with Bad Weather Brewing and Lucid Brewing. Two years later, Badger Hill moved to 4571 Valley Industrial Boulevard in Shakopee, where it occupies approximately thirteen thousand square feet for its microbrewery operations and taproom. It is neighbors to Canterbury Park and Valley Fair.

Badger Hill's brewing output was about three thousand barrels in 2017. "Our maximum capacity far exceeds six thousand barrels with the most recent expansion and with the Finnegans partnership we're looking to do twelve thousand barrels total out of the Shakopee facility this year," the

company said.[66] Its beers are distributed via kegs and twelve-ounce cans. The brewery's owners are Britt Krekelberg, Broc Krekelberg, Michael Koppleman and Brent Krekelberg.

Business hours: Tuesday through Thursday 3:00 p.m.–10:00 p.m.; Friday and Saturday 12:00 p.m.–11:00 p.m.; Sundays 11:30 a.m.–10:00 p.m. Closed Mondays.

Fun fact: Badger Hill buys most of its malt and hops from Rahr Malting, which is also located in Shakopee.

Specialty beers: Badger Hill brews a wide range of beers from a hoppier signature called Traitor IPA to balanced beers such as High Road and a black beer named Foundation Stout.

Website: badgerhillbrewing.com

BANG BREWING COMPANY

Don't look for co-owners Sandy and Jay Boss Febbo (also wife and husband) to take Bang Brewing on any growth binge. They pride themselves on operating a small microbrewery.

"We scaled our brewery [which opened in September 2013] with a goal of remaining hyper local and we're designed to thrive doing so. Our goal has always been to have the biggest impact with the smallest footprint," Sandy said. "We brew 10-barrel batches. Our facility is designed to produce 500 barrels annually and have options to expand production beyond that on site

Bang Brewing Company's corrugated steel corn crib reflects its commitment to using all organic ingredients in its beers. *Bang Brewing Company.*

should we determine to do so. It's an awesome exercise in maximizing space and process efficiencies."

The seeds for Bang Brewing date back to 1993 when Sandy and Jay began small-batch brewing. By 2005, Sandy and Jay's hobby morphed into plans to open a microbrewery. In 2012, the couple broke ground for Bang Brewing in St. Paul's industrial district north of University Avenue.

Business hours: Thursdays 4:00 p.m.–10:00 p.m.; Fridays 4:00 p.m.–10:00 p.m.; Saturdays 2:00 p.m.–10:00 p.m.

Fun fact: "Bang Brewing Company is Minnesota's only dedicated organic brewery," Sandy said. The brewery uses all organic ingredients in its beers, part of the company's eco-friendly focus. (That's why you'll see a corrugated steel corn crib as a part of its brewery facilities.)

Specialty brews: A range of high-quality rustic ales and lagers—unfiltered, unpasteurized and naturally carbonated without the use of any finings.

Website: bangbrewing.com

BARLEY JOHN'S BREW PUB

John Moore and his wife, Laura Subak, founded Barley John's Brew Pub in 2000.

After years of homebrewing and a degree in nutritional sciences from the University of Michigan, Moore completed coursework from the Siebel Institute of Brewing Sciences.

After brewing for the now defunct District Brewing in downtown Minneapolis and James Page Brewing (Northeast location), Moore employed his passion and experience to launch Barley John's Brew Pub. Along with help from wife and partner Laura and countless friends and family, Barley John's Brew Pub debuted on March 14, 2000.

Barley John's Brewpub has brought craft beer to New Brighton. *Author's collection.*

Moore and his team have grown their original brewery vision by adding a vegetable garden for fresh seasonal produce and a fully maxed out facility for brewing production in the current New Brighton space. To accommodate additional production, Barley John's built a thirteen-thousand-square-

foot brewery and taproom in 2014 across the border in neighboring Wisconsin. That facility, called Barley John's Brewing Company, has a brewing capacity for ten thousand barrels annually. Moore decided to build his brewery in Wisconsin because Minnesota law doesn't allow brewpubs to sell directly to bars and liquor stores.[67]

New Brighton business hours: Monday through Saturday 11:00 a.m.–1:00 a.m.; closed Sundays.

Specialty brews: The brewery has four flagship recipes as well as up to an additional four to seven seasonal recipes at any given time.

BAUHAUS BREW LABS

Bauhaus Brew Labs logo.
Bauhaus Brew Labs.

Founded in mid-2014, Bauhaus Brew Labs is a family affair with its owners a mix of musicians, scientists, artists and beer lovers.

After graduating from law school and spending a few years as a practicing attorney, head brewer and CEO Matt Schwandt decided to take his passion of homebrewing to commercial scale. With the help of Matt's family, Bauhaus Brew Labs was born. Co-owners with Matt Schwandt are Lydia Haines, Michael Schwandt, Maura Hagerty Schwandt, Mark Schwandt, Leah Haines, Howard Haines and Kathryn Haines.

"We were inspired to create Bauhaus Brew Labs by Germany's Bauhaus School (which briefly operated in post World War II), which was one of the most famous art and design schools in pre–World War II Germany," Maura said. "The Bauhaus school was inspiring…because it was fueled by a commitment to creativity and experimentation with the underlying tenet that work, play and celebration should all be intertwined. At Bauhaus Brew Labs, we live by the Bauhaus concept that the joy of art and craft should be celebrated in everyday life."

Located at 315 Tyler Street NE, Minneapolis, Bauhaus Brew Labs features German-inspired beer styles, including flavorful and crisp lagers. In its first couple years, the company carried out its Twin Cities' business through self-distribution and has used the St. Paul–based Artisan Beer Company as its distributor to greater Minnesota.

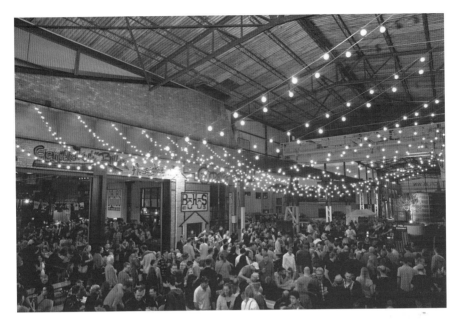

A packed patio demonstrates the popularity of Bauhaus Brew Labs. *Bauhaus Brew Labs.*

But after tripling its cellar space three times in two and a half years, Bauhaus hit a wall for further expansion. In November 2016, Bauhaus's owners struck a deal with Artisan Beer to also handle the brewery's Twin Cities distribution. That move has proven brilliant. In 2016, Bauhaus's brew production topped 8,550 barrels, a 61.1 percent increase over 2015. Last year (2017), Bauhaus produced 8,910 barrels.

Business hours: Wednesdays and Thursdays 4:00 p.m.–11:00 p.m.; Fridays 3:00 p.m.–11:00 p.m.; Saturdays 12:00 p.m.–11:00 p.m.

Fun facts: Bauhaus Brew Labs was built on a former industrial site that was home to the Crown Iron Works company, which was founded in the 1870s by two Swedish men, Andrew Nelson and August Malmsten. Bauhaus throws several tentpole parties throughout the year with its annual "Liquid Zoo Art-A-Whirl Celebration" in May, drawing more than twenty-five thousand people.

BENT BREWSTILLERY

Bent Brewstillery is located in Roseville. It is the product of a merger with the former Pour Decisions Brewing Company. *Author's Collection.*

Bent Brewstillery is the product of a 2014 merger with Pour Decisions Brewing Company in Roseville. The brewery is unique because it produces beers *and* spirits.

Owner and president Bartley Blume says his serendipitous foray into the brewing world began in 2007 when his wife gave him a beer-brewing kit for Christmas. He admits his first batch of ale, brewed in February 2008, "tasted horrible, so I dumped it and started over. The next one was great and I never looked back."

After more than a year of puttering on the side with homebrewing and distilling and enjoying it more each day, Blume decided to "shed the shackles of corporate bondage to do my own thing."

"My business plan was written in 2009 and I started execution in 2012," Blume said. "By 2013 I had beer on the market and started making spirits by mid-2014."

Currently, Bent Brewstillery occupies about 7,500 square feet of warehouse space at 1744 Terrace Drive in Roseville. Its brewhouse uses a two-vessel twenty-barrel system that fills four forty-barrel conical fermenters plus a five-barrel pilot system that fills a five-barrel conical fermenter used mainly for sour beers.

The merger of Bent Brewstillery and Pour Decisions brought fresh capital to the existing Pour Decisions brewery, allowing for expansion and renovation. Pour Decisions owner Kris England has stayed on in the operations as head brewer.

Since the merger with Pour Decisions, Bent Brewstillery's production has doubled. As of this writing, Brewstillery is producing about 150 barrels per month.

Blume says his brewery's niche is "randomness. We've got all different types of styles and if you're not around for a couple weeks, you'll miss a small batch beer. We do a lot of sours and lots of barrel-aged beers."

Business hours: Tuesdays through Thursdays 4:00 p.m.–10:00 p.m.; Fridays 2:30 p.m.–12:00 a.m.; Saturdays 12:00 p.m.–12:00 a.m.; and Sundays 12:00 p.m.–7:00 p.m.

Fun fact: Bent Brewstillery was named Minnesota's Distillery of the Year at the New York International Spirits Competition.

Website: bentbrewstillery.com

Big Wood Brewing

Big Wood Brewing occupies a historic building in downtown White Bear Lake. *Author's collection.*

In proximity to White Bear Lake, Big Wood Brewing is among Minnesota's oldest microbreweries in the new millennium brewing boom. It was established in 2009 by Steve Merila and Jason Medvec, becoming the nineteenth brewery then in the state.[68]

Located at 2222 Fourth Street in the city of White Bear Lake, Big Wood Brewing occupies a historic building that dates back to the 1920s and once housed a YMCA. The brewery prides itself on "having a variety of styles, something for everyone to enjoy," said taproom manager Karsten Jepsen. "We have 30-plus recipes, meaning our tap lines are constantly rotating based on season and availability of ingredients. We are always looking for new styles of beer to brew or variations/improvements for the styles we already have."

Since its startup, Big Wood has had strong community support and its local success has gradually grown so that it now has nearly statewide distribution. "However, over one hundred breweries have opened in Minnesota since we began, so growth has been difficult the past few years," Jepsen said.

Currently, Big Wood produces an average of two hundred barrels per month.

Business hours: Tuesday through Thursday 4:00 p.m.–10:00 p.m.; Fridays 3:00 p.m.–11:00 p.m.; Saturdays 1:00 p.m.–11:00 p.m.; Sundays 12:00 p.m.–6:00 p.m. Closed Mondays.

Website: bigwoodbrewery.com

BOOM ISLAND BREWING COMPANY

For founder and head brewer Kevin Welch, Belgium was the inspiration for launching a microbrewery. Some seventeen years ago, Welch tasted his first Belgium tripel, an event that he said was a life-changing experience. That's when he dreamed of the day of being able to brew his own Belgium-inspired beers.

"Before starting Boom Island, Kevin travelled to 13 breweries across Belgium to brew side-by-side with the leading innovators in Belgian brewing," according to Boom Island's website. "He also brought home the ultimate souvenir: nine strains of yeast from their source breweries. Today, Kevin uses several of those strains to produce the elusive qualities only found in beer from the breweries of their origin."

Welch runs Boom Island Brewing with his wife, Qiuxia (pronounced Choo Sha). Qiuxia oversees the brewery's business and marketing operations. In the initial business startup, Qiuxia's parents left their home in Chengdu, China, to help build the brewery.

Located at 2014 Washington Avenue North in Minneapolis, Boom Island's beers are naturally carbonated and bottle conditioned. The brewery adds live yeast before the beers are bottled, giving them fresher tastes with flavors that evolve over time, the Welches said.

Business hours: Wednesday through Friday 4:00 p.m.–9:00 p.m.; Saturdays 1:00 p.m.–9:00 p.m.; Sundays 1:00 p.m.–6:00 p.m.

Website: boomislandbrewing.com

DANGEROUS MAN BREWING COMPANY

Rob Miller joined the growing list of homebrewers and microbrewery entrepreneurs when he opened Dangerous Man Brewing Company in early 2013. Miller's brewery opening was spurred by changes in state law that permitted brewery taprooms and changes in Minneapolis city ordinances that permit breweries to locate across the street from churches.

Miller and his co-owner and wife, Sarah Bonvallet, said there is a constantly changing chocolate menu of beers that are served at Dangerous Man. "Peanut Butter Porter and Milk Stout are customer favorites, so we try to keep those on tap," Bonvallet said. "Our niche is that we do not distribute

Dangerous Man Brewing Company has been open since 2013. *Dangerous Man Brewing Company.*

our product outside of the taproom or growler shop, so you have to come and visit us for a taste!"

Since its debut, Dangerous Man has enjoyed steady growth. "In April 2015, we expanded into an adjacent building to open a dedicated storefront for growler and merchandise sales," Bonvallet said. "The expansion was completed in November 2015, doubling our overall footprint of the brewery and tripling brewing capacity." Currently, Dangerous Man brews about 165 barrels a month.

Business hours: Tuesday through Thursday 4:00 p.m.–10:00 p.m.; Fridays 3:00 p.m.–12:00 a.m.; Saturdays 12:00 p.m.–12:00 a.m.; Sundays 12:00 p.m.–8:00 p.m.

Fun fact: Dangerous Man Brewing took up residence in a turn-of-the-twentieth-century building at 1300 Second Street NE that was originally home to the Northeast Bank.

Website: dangerousmanbrewing.com

Eastlake Craft Brewery

Eastlake Brewing logo. The brewery produces small batches of a variety of beers with its seven-barrel electric system. *Eastlake Brewing.*

Owner and brewer Ryman Pittman opened Eastlake Craft Brewery in December 2014 at East Lake Street's Global Market (920 East Lake Street #123).

"My motivation [in opening Eastlake brewery] was to make a career out of a hobby I enjoyed, and to do it in a place where we could help bring community together," Pittman said.

Currently, Eastlake produces small batches of a variety of beers with its seven-barrel electric system from Stout Tanks of Portland, Oregon. All electricity used in Eastlake's brewing process comes from sustainably-sourced wind energy, Pittman noted. In 2017, Eastlake produced almost one thousand barrels of beer.

Business hours: Monday through Sunday 12:00 p.m.–11:00 p.m.

Fun fact: The brewery's location at the Global Market puts it in immediate proximity to more than a dozen restaurants.

Specialty brews: The brewery focuses on what Pittman calls "post-modern American styles," including "a sour or two, three or four takes on IPA, and other American and Belgian styles. Our sours are our Kirby Pucker series. Our annual winter release is Tsathoggua, an Imperial Stout aged on oak and Spanish Brandy."

Website: eastlakemgm.com

Excelsior Brewing Company

Excelsior Brewing Company logo. *Excelsior Brewing Company.*

Excelsior Brewing Company celebrates its sixth anniversary on June 30, 2018. Its genesis was sparked after one of its co-owners, John Klick, attended some brewers' conferences. Other co-owners are Patrick Foss and Jon Lewin.

The brewery has four lake life–focused beers, and Klick said their business has enjoyed "exponential growth," now producing more than four hundred barrels a month. Located at 421 Third Street, Excelsior, Excelsior Brewing said its mission is to "celebrate the rich history of Lake Minnetonka and historic Excelsior by delivering superior brews hand-crafted in their image. Our brew was created to honor lake life and ultimately to complement it."

Business hours: Tuesdays 4:00 p.m.–9:00 p.m., Wednesdays and Thursdays 4:00 p.m.–10:00 p.m., Fridays and Saturdays 12:00 p.m.–11:00 p.m.; Sundays 12:00 p.m.–6:00 p.m.

Website: excelsiorbrew.com

Fulton Brewing Company

Located within eyeshot of Target Field in downtown Minneapolis, Fulton Brewing Company has come a long way since it debuted in 2009.

Fulton Brewing's roots date back three years earlier when Jim Diley—with the help of college buddies Ryan Petz, Brian Hoffman and Peter Grande—began homebrewing, ten gallons at a time, out of his single-car garage in Minneapolis.

Fulton Brewing growler. *Fulton Brewing Company.*

Initially, the four men had no intention of starting a brewery, but then they serendipitously discovered they had assembled a team that might be able to pull off such a venture. Diley had the big ideas, Grande built the equipment, Petz dreamed up recipes and Hoffman drank the beer.

After an encouraging reception from family and friends, the four men took the plunge and started Fulton Brewing (named after their Minneapolis neighborhood), first contracting with Sand Brewing Company in western Wisconsin to use its facilities for brewing before later building their own microbrewery.

"We were able to apprentice with an experienced brewmaster, learn the basics of operating a production plant, build distribution, and generate some revenue," the men said. "We sold our first pint of Sweet Child of Vine on October 28, 2009."

Less than three years later, Fulton Brewing opened as Minneapolis's first official taproom. And in September 2013, Fulton Brewing's owners got the keys to a fifty-one-thousand-square-foot building in northeast Minneapolis that serves as headquarters for its offices, brewing laboratory

and eighty-barrel brewery production facility.[69] Also, the company's downtown microbrewery now serves as its lab for smaller batch and experimental brewing, including taproom exclusives and barrel aging.

In 2017, Fulton Brewing produced about 29,250 barrels of beer. In the last five years, the brewery's annual production has averaged 25 to 45 percent growth, Petz told *Twin Cities Beer*. "We have tripled the industry average growth rate."

Business hours: Tuesday through Friday 3:00 p.m.–10:00 p.m.; Saturdays 12:00 p.m.–11:00 p.m.; Sundays 12:00 p.m.–6:00 p.m.

Fun facts: Fulton Brewery sells about twenty-one thousand servings of beer daily, the company said. Also, Mike Salo, Fulton's first head brewer, is a part of Fulton's ownership group.

Website: fultonbeer.com

HammerHeart Brewing Company

HammerHeart Brewing Company is located in Lino Lakes and has been serving Norse-inspired beers since the summer of 2013. *Author's collection.*

Since its debut, HammerHeart Brewing has been producing and serving a blend of Norse-inspired beers with a dollop of black metal music entertainment at the company's taproom in Lino Lakes.

Co-owners Nathaniel Chapman and brother-in-law Austin Lunn were disillusioned with their professional lives and sought out more creative work. Both men, who had been homebrewers, thought that opening their own brewery establishment could be the answer. And Lunn was convinced that especially made sense after he interned at the Haand Bryggeriet Brewery in Norway.

When Lunn returned to the United States, he moved from Kentucky to Minnesota and began plans to launch HammerHeart Brewing. After about two years of planning and construction, the HammerHeart brewery opened in late summer of 2013 with Lunn's Norwegian mentor assisting him in brewing three collaborations.

Currently, HammerHeart is brewing about eight hundred barrels per year. It boasts about a one-thousand-square-foot taproom modeled after an old drinking hall. As of this book's publication, HammerHeart beers were on tap at more than two dozen restaurants and bars in the Twin Cities.

Business hours: Tuesday through Saturday 2:00 p.m.–10:00 p.m.; Sundays 12:00 p.m.–8:00 p.m.

Specialty brews: The brewery offers Norse- and Celtic-inspired beers, including one it calls "Black Cascade Cascadian Dark Ale," a signature metal beer.

Fun fact: The brewery's name comes from the Swedish metal band Bathory, which recorded an album titled *Hammerheart*. Lunn is the soloist to his own metal band called Panoptican.

Website: hammerheartbrewing.com

Inbound Brew Company

Owners Jon Messier and Eric Biermann opened Inbound Brew Company on April 22, 2016, the latest stop they have had in heeding the call of beer.

"Beer talked us into quitting our jobs, leaving corporate America in the rearview mirror and opening a brewery in the burbs," the two men said of the brewery they once called Lucid Brewing. "Then into helping our pals open their breweries. Then into buying a brewery in Wisconsin. Then into opening a brewery [Inbound] in Minneapolis. When we journey into beer, we go all in."

Since opening their commercial brewery, Messier and Biermann have focused their business on brewing small batches of craft beer, ten to fifteen barrels at a time. "In our first year we saw production around 1,500 barrels of beer," said Spencer Ploessl, Inbound's former marketing communications director.

Located at 701 North Fifth Street in Minneapolis, Inbound brews more than twenty craft beers with its catalogue of brews ranging from a Cranberry Orange Tart to a ruby-red Hibiscus Saison. "Eventually we'll fill all of them [taps], of which that would be 32 total beers on tap," Ploessl said.

Business hours: Monday through Friday 12:00 p.m.–12:00 a.m.; Saturdays and Sundays 11:00 a.m.–12:00 a.m.

Website: inboundbrew.co

INDEED BREWING COMPANY

Nathan Berndt and Tom Whisenand launched Indeed Brewing Company in August 2012.

Whisenand and Berndt, who both had been homebrewers, brought on Josh Bischoff as their head brewer. Bischoff had more than twelve years of professional brewing experience. Rachel Anderson rounded out the startup team in creating the logo and branding for Indeed Brewing.

Bischoff's experience is reflected in the several distinctive recipes that he uses at Indeed, many that are made with honey. They include some of Indeed's most popular beers like LSD, Mexican Honey and Shenanigans. Indeed is also well known for its seasonal beers and barrel-aged wild and sour program called Wooden Soul, according to Kelly Moritz, Indeed's marketing and communications manager.

Currently, Indeed Brewing produces 1,500 to 2,000 barrels of beer per month.

"Indeed has seen tremendous growth over the four plus years we've been in business, and we're only continuing to grow and expand in capacity and territory," Moritz said, noting the company has about fifty employees and

Warehouse worker at Indeed Brewing Company plant. *Indeed Brewing Company.*

distributes its beers in three states. "Indeed aims for sustainable growth and while staying true to its roots."

Indeed Brewing is also a community-centered brewery. It has a charitable giving program where 100 percent of its profits on Wednesdays go to an employee-sponsored local nonprofit.

Business hours: Wednesdays and Thursdays 3:00 p.m.–11:00 p.m.; Fridays and Saturdays 12:00 p.m.–11:00 p.m.; Sundays 12:00 p.m.–8:00 p.m.

Fun fact: Indeed Brewing Company was the first microbrewery to open a taproom in Northeast Minneapolis. It is located at 711 Fifteenth Avenue NE.

Website: indeedbrewingin.com

Insight Brewing Company

Founded in November 2014, Insight Brewing Company is located at 2821 East Hennepin Avenue.

Insight is dedicated to "bringing the world of beer back to Minnesota," said Ilan Klages-Mundt, brewery co-founder and co-owner with Brian Berge and Eric Schmidt. "We've brewed with breweries all around the world and continue to reach out further and further each year, always striving to learn the insight to the world of beer."

For example, Ilan has traveled and apprenticed at breweries in Europe and Japan. Today, Insight's stable of beers includes Sunken City Saison, brewed with Sauvignon Blanc grapes; Banshee Cutter Coffee Golden Ale and Troll Way Citrus IPA.

Insight Brewing Company. In its first three years in business, the brewery has had more than 100 percent annual growth. *Insight Brewing Company.*

As of April 2018, Insight Brewery was producing about eight hundred to one thousand barrels a month. "To date, we've grown more than 100 percent each year," Ilan said. "While we won't be able to continue that aggressive growth, we did achieve the spot of third fastest growing brewery in Minnesota in 2017." Business hours: Monday through Thursday 3:00 p.m.–11:00 p.m.; Fridays 3:00 p.m.–12:00 a.m.; Saturdays 12:00 p.m.–12:00 a.m.; Sundays 12:00 p.m.–11:00 p.m.

Fun fact: Ilan's last name, Klages, is a type of brewers' barley.

Website: insightbrewing.com

LAKE MONSTER BREWING COMPANY

Lake Monster Brewing began with contract brewing from October 2013 until December 2015, then opened its production brewery and taproom in Saint Paul (at 550 Vandelia Street).

The company's name picks up on the general public's fascination with lake-dwelling cryptids, animals that are said to exist based on anecdotal evidence. "While skeptics might consider the existence of Lake Monsters to be exaggerations, misinterpretations or even fabrications, other people see a world of mysteries yet to be solved and depths yet to be explored," said company officials. "These intrepid souls think it is worth the effort to venture beneath the surface in search of something unknown and extraordinary. We feel the same way about beer."

Lake Monster Brewing Company employs colorful packaging on its various beer cans. *Lake Monster Brewing Company.*

Lake Monster specializes in brewing classic-style beers with a not-so-subtle twist. In its first eighteen months of operations, the brewery quadrupled its business.

The brewery's penchant for the offbeat is reflected in its corporate structure: Jeremy Maynor is Lake Monster's CFO or "chief fun officer," while co-owner Matt Zanetti is COO or "chief obligation officer." (Company brewmaster is Matt Lange.)

Zanetti, the son of a Napa Valley vineyard manager, thought about getting into the brewing business for several years. "Not knowing how to make beer, I was introduced to my now partner and brewmaster Matt Lange," Zanetti said. Like many other brewers, Lange started homebrewing and then after graduating from University of Wisconsin–Madison in 2008 with an English literature degree found the job market a little tight. He got a job at Ale Asylum, a startup brewery in Madison. He left there to start Lake Monster and moved back to the Twin Cities with his wife, Zanetti said.

Business hours: Monday through Thursday 4:00–10:00 p.m.; Fridays 2:00 p.m.–12:00 a.m.; Saturdays 12:00 p.m.–12:00 a.m.; Sundays 12:00 p.m.–8:00 p.m.

Website: lakemonsterbrewing.com

LAKES & LEGENDS BREWING COMPANY

Lakes & Legends Brewing Company is the first member of Minnesota Grown, a group put together by the Minnesota Department of Agriculture. *Lakes & Legends Brewing Company.*

Debuting in December 2015, Lakes & Legends Brewing Company focuses on producing farmhouse and Belgium-inspired beers, featuring ingredients from local growers.

"We're actually the first brewery member of Minnesota Grown, a group put together by the Minnesota Department of Agriculture," said Ethan Applen, the brewery's CEO and co-owner with his mother, Kathleen Applen, and business associate Derrick Taylor.

Located at 1368 Lasalle Avenue in Minneapolis, Lakes & Legends in 2017 "saw strong growth driven by our loyal fans and community, and we hope to see continued growth in 2018," Applen said, noting the brewery introduced cans this spring.

"Having become an avid pursuer of all beer Belgian, and having brewed them at home, I realized that there were other people out there that thought they didn't like 'Craft Beer' just because they associated IPAs with them.… The idea was born to create a beer lineup that was approachable from a flavor standpoint, featured locally grown ingredients as much as possible, and paired well with food."

Business hours: Tuesday through Thursday 3:00 p.m.–10:00 p.m.; Fridays 3:00 p.m.–12:00 a.m.; Saturdays 12:00 p.m.–12:00 a.m.; and Sundays 12:00 p.m.–10:00 p.m.

Specialty beers: One of the brewery's most popular beers is its St. Gail, a raspberry braggot (or honey ale) made from real raspberries and bounteous amounts of honey that Lakes & Legends gets from the Ames Farm in Delano, Minnesota.

Website: lakesandlegends.com

Lift Bridge Brewing Company

Founded in 2008, Lift Bridge Brewing Company is the first brewery in Stillwater since the Prohibition era.

Lift Bridge also claims to have Minnesota's oldest taproom and one of the state's oldest barrel-aging programs in Minnesota. "Our barrel-aged Silhouette is rated in the top 250 beers in the world," said brewery spokeswoman Katie Schwarz.

Lift Bridge logo. *Lift Bridge Brewing Company.*

The brewery's owners are Brad Glynn, Dan Schwarz, Jim Pierson and Trevor Cronk. "Brad Glynn's father Jeff Glynn was in the brewing business his whole life and Brad was interested in starting a brewery in Stillwater," Katie Schwarz said. He recruited his friends and neighbors Dan, Jim and Trevor to join him.

Located at 1900 Tower Drive West in Stillwater, Lift Bridge produced about 1,250 barrels in 2016, with that production jumping to about eighteen thousand barrels in 2017, according to Dan Schwarz. In early 2018, the brewery announced plans to expand into a new facility that is expected to open sometime in 2019.

Business hours: Monday through Thursday 3:00 p.m.–10:00 p.m.; Fridays and Saturdays 12:00 p.m.–10:00 p.m.; Sundays 12:00 p.m.–6:00 p.m.

Specialty beers: Lift Bridge's flagship beer is called Farm Girl Saison. "We generally like to create balanced beers with layers of flavors," Schwarz said.

Website: liftbridgebrewery.com

LTD BREWING

Logo for LTD Brewing. The company's letters stand for "live the dream." *LTD Brewing.*

LTD Brewing debuted in 2014 in downtown Hopkins, occupying about three thousand square feet at a former floral shop, with that space equally divided between its taproom and microbrewery.

For LTD founders Jeremy Hale and Blake Verdon, their passion for brewing began a decade earlier when the two University of Minnesota roommates were looking for a cheaper way to get beer.

"We needed a relatively inexpensive/legal way to obtain beer, so we thought 'Why not brew our own?'" they said. Initially, they didn't care how their brews turned out. But the deeper they got into their homebrewing, the more they wanted to produce beers that tasted good and pushed the limits of their all-grain concoctions with new and innovative ingredients, inventing their own styles of beer.

Once Hale and Verdon could consistently replicate their successful beers, they sought to take their craft to the next level and share it with the beer-consuming public. Today, LTD uses its flexible, eight-barrel brewing system to make a rotating variety of beers, including "always having something light, something malty, something bitter, something dark, and something you've never had before."

LTD produced about eleven hundred barrels of beer in 2017 and anticipates increasing its production to twelve hundred barrels in 2018, Hale said.

Fall/spring business hours: Mondays and Tuesdays 4:00 p.m.–9:00 p.m.; Wednesdays 4:00 p.m.–10:00 p.m.; Thursdays 3:00 p.m.–10:00 p.m.; Fridays 2:00 p.m.–12:00 a.m.; Saturdays 12:00 p.m.–12:00 a.m.; Sundays 12:00 p.m.–7:00 p.m.

Fun fact: LTD stands for "live the dream."

Website: ltdbrewing.com

LynLake Brewery

Mark Anderson and Paul Cossette, co-founders of LynLake Brewery, met early in their careers as construction workers helping build the landmark high-rise Wells Fargo Center (formerly known as Norwest Center) in the early 1980s.

After becoming good friends through two decades of working on other high-rise construction projects, the two men had a dream to build something that they could own: a brewery. Their vision was more than mere idle talk; they found a building for their brewery and soon brought on Joel Carlson as their head brewer to lead their team.

Thus began the work of building a pilot brewing system, designing and constructing the brewery space, licensing, branding the idea and, most importantly, building a roster of unique, well-crafted beers.

Located in the historic Lyndale Theater (which dates back nearly one hundred years) in the LynLake neighborhood of Minneapolis, the brewery opened in October 2014. "We love the craft beer industry and craft beer.

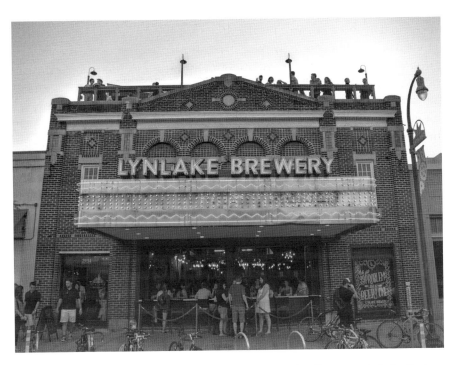

Now playing at the former Lyndale Theater: LynLake Brewing Company. *Author's collection.*

We wanted to make great beer and establish a great place to drink it," Anderson said.

Currently, LynLake Brewery is producing about one hundred barrels of beer per month. Its business is averaging 2 to 3 percent annual growth, largely due to it only operating a taproom with no distribution.

Business hours: Thursdays 5:00 p.m.–10:00 p.m.; Fridays 2:00 p.m.–1:00 a.m.; Saturdays 12:00 p.m.–1:00 a.m.; Sundays 12:00 p.m.–10:00 p.m.

Fun fact: LynLake Brewery has a rooftop patio with ample space for its patrons to kick back and relax.

Website: lynlakebrewery.com

MAPLE ISLAND BREWING COMPANY

Located in the historic Maple Island Creamery building on Main Street in downtown Stillwater, Maple Island Brewing Company opened in September 2014.

Co-owner Frank Fabio came up with the idea for the microbrewery and taproom after buying the former creamery as home for his fire and water restoration company and discovering there was plenty of additional space to accommodate another business. Inspired by his love of craft beer and backed with the help of family and friends, Fabio opted to start up Maple Island Brewing.

Maple Island co-owner Nic Brau recalled, "I first tried really good beer years ago in Lucan, Minnesota where Brau Bros Brewing was located. We used to go there all the time after pheasant hunting trips, but the location was so far away I started brewing myself."

In 2017, Maple Island Brewing produced about 450 barrels and has enjoyed steady growth, according to its owners.

Winter taproom hours: Tuesday through Thursday 3:00 p.m.–9:00 p.m.; Fridays and Saturdays 12:00 p.m.–10:00 p.m.; Sundays 12:00 p.m.–8:00 p.m. Summer hours: Sundays and Mondays 12:00 p.m.–8:00 p.m. and Tuesday through Saturday: 12:00 p.m.–10:00 p.m.

Specialty beers: When possible, Maple Island tries to use local ingredients in brewing its beers. Among its more unusual offerings are an ice cream beer, a real maple syrup beer with local maple syrup, a kolsch with honey malts, a wheat IPA with chamomile and a wit beer with hand-peeled fruit.

Website: mapleislandbrewing.com

Modist Brewing Company

Logo for Modist Brewing Company. *Modist Brewing Company.*

Just a stone's throw away from Target Field in downtown Minneapolis, Modist Brewing Company burst on the scene in April 2016 and quickly established itself as a distinctive destination.

Beer Advocate named Modist as one of the top breweries opening in the United States in 2016. It achieved that honor in a year when nearly nine hundred new breweries joined the ranks of America's burgeoning beer industry.

Located at 505 North Third Street, Modist Brewing has an eighteen-thousand-square-foot brewery and taproom. Its owner/management team is Eric Paredes, chief manager; Keigan Knee, head brewer; Kale Anderson, head of operations; and John Donnelly, head of sales.

Modist Brewing's owners said that "a mutual love for locally-made, hand-crafted things serendipitously brought us together over six years ago as volunteers at a then newly-launched brewery. An insatiable curiosity drove us all to explore different aspects of the brewing business and we soon enough committed to opening our own venture."

Their brewing philosophy is rooted in the word *modify*. "Everything we do—in our personal lives and in our brewing—is an intentional break from the norm," the owners told me. "Years spent at various breweries in the area taught us what beer is, but we wanted to learn what beer can be. So, we set out to explore and push the envelope."

After its first year in business, Modest owners said they have had tremendous customer reception to their brewery; in 2017, the brewery produced 2,056 barrels of beer. The brewery's annual production stretch goal, given its recent expansion, is 10,000 barrels, said Modist's Dan Wellendorf.

Business hours: Closed Mondays except for Minnesota Twins' home games; Tuesday through Thursday 4:00 p.m.–10:00 p.m.; Fridays 12:00 p.m.–12:00 a.m.; Saturdays 12:00 p.m.–12:00 a.m.; Sundays 12:00 p.m.–8:00 p.m. Open two hours before all Twins' home games.

Fun fact: Modist Brewery boasts the Twin Cities region's first mash filter, making it one of the most technologically advanced brewhouses in the area, according to its owners. That piece of equipment allows its brewers

to use any grain in any percentage—and do so while using a fraction of the water and energy of a traditional brewery.

Specialty beers: Modist's small-batch, taproom-only "Deviation" series of beers. Deviation beers are given a number and are only christened and produced in larger quantities if they are a hit with Modist's customers.

Website: modistbrewing.com

Omni Brewing Company

Omni Brewing Company is the first microbrewery in Maple Grove.

Located at 9462 Deerwood Lane North, Omni Brewing opened in September 2015, a venture that owners Zack Ward, Justin Walsh and Steve Hayes started out of self-interest.

"We all lived in the Northwest suburbs of Minneapolis and felt that we shouldn't have to drive in to the city of Minneapolis to get a craft beer," Hayes said. "Zack had been an avid homebrewer for eight years and had always dreamed of having his own taproom and the rest is history."

So far, Omni Brewing is producing fifty to eighty barrels per month and with its 5,800-square-foot warehouse will have enough space to eventually

Omni Brewing Company is the first microbrewery in Maple Grove. The three cans represent some of its most popular brands. *Omni Brewing Company.*

boost production to five thousand barrels annually and add a canning line. Business is growing at about a 20 percent annual rate.

The brewery prides itself on being a family friendly business, accessible to everyone and active in the community. Every month, it takes on a service project with taproom volunteers.

Business hours: Tuesday through Thursday 3:00 p.m.–10:00 p.m.; Fridays 12:00 p.m.–11:00 p.m.; Saturdays 12:00 p.m.–11:00 p.m.; Sundays 12:00 p.m.–10:00 p.m.

Fun fact: Electricity from Omni's brewery is generated by eighty-six solar panels, the largest dedicated array of solar panels for any brewery in Minnesota.

Specialty beers: Omni's owners say they take classic favorite style beers "and amp them up a bit to make them special." Their most popular beers include Lake Day, a pale ale/cream ale hybrid, and Muddy Runner, an American porter with toasted coconut.

Website: omnibrewing.com

Sisyphus Brewing

Sisyphus Brewing debuted in July 2014, taking its inspiration from the Greek legend of Sisyphus, who is condemned to push a rock up a hill for eternity, and the French philosopher Albert Camus's musings on that tale.

Whenever Sisyphus gets the rock up to the top of the hill and lets it go, the rock tumbles all the way back down the hill, and the journey starts all over again. Camus saw that tale as a metaphor for the human condition; people toil each day only to do it all over the next day, no matter the victories or defeats of the previous day.

On their website, Sisyphus Brewing's owners muse, "With the realization that life has no meaning, comes an opportunity, you can create your own meaning, and occupy yourself fully with the burden, the rock, in front of you. To truly live is to throw yourself head on into what can distract you from the meaninglessness of a single human life in a constantly expanding, nearly infinite universe."

Sam Harriman, brewery co-owner, told *Growler* magazine, "Sisyphus is being punished, but we choose our setting." In Harriman's case, he abandoned an unsatisfying corporate career to pursue life as a full-time stand-up comic. Located in Minneapolis's Loring Park neighborhood, Sisyphus Brewing has enjoyed steady growth.

Sisyphus Brewing takes its inspiration from the Greek legend of Sisyphus. *Sisyphus Brewing.*

Business hours: Monday through Wednesday 3:00 p.m.–10:00 p.m.; Thursdays 3:00 p.m.–11:00 p.m.; Fridays and Saturdays 12:00 p.m.–12:00 a.m.; Sundays 12:00 p.m.–6:00 p.m.

Fun fact: The Sisyphus Brewing taproom has become one of the Twin Cities' leading venues for comedy shows, with the brewery hosting open mic night for amateurs and booking emerging stand-up comics. In the summer of 2016, Sisyphus opened an eighty-eight-person comedy room, a move that puts generating laughs on equal footing with selling lagers.

Website: sisyphusbrewing.com

612 BREW

When 612 Brewing Company opened in February 2013 at 945 Broadway Street NE, microbreweries were still somewhat of a rarity in the Twin Cities.

"We got started due to the lack of Minneapolis-made craft beer," said Robert Kasak, a co-owner of 612 Brewing. "When we broke ground at our brewery there were only two production breweries and three brew pubs in the entire city of Minneapolis. And only two production breweries in St Paul and only one brewpub. Clearly we needed to change that."

Since its debut, 612 Brewing has enjoyed steady growth. Kasak and fellow co-owners Adit Kalra and Jamey Rossbach have expanded the brewery,

612 Brewing. *612 Brewing.*

adding new tanks, packaging lines, a beer separator and an upgraded brewhouse system to increase capacity and constantly improve quality.

Less than a year after opening, 612 Brewing added another two thirty-barrel fermenters and one thirty-barrel bright tank, increasing production capacity by over 65 percent.

The brewery now has the capacity to produce up to three thousand barrels per year, Kasak added.

Business hours: Monday through Thursday 4:00 p.m.–10:00 p.m.; Fridays 2:30 p.m.–12:00 a.m.; Saturdays 12:00 p.m.–12:00 a.m.; Sundays 12:00 p.m.–8:00 p.m.

Fun fact: 612 Brewing's taproom features beer-inspired murals painted by local artists Adam Turman and David Witt, aka DWITT. "The taproom looks directly upon our mirror polished fermentation tanks and visitors can watch the beer be made right in front of them," Kasak said.

Specialty brews: The brewery focuses "on hop forward" American ales, Belgian-style beers and traditional lagers.

Website: 612brew.com

SOCIABLE CIDER WERKS

Logo for Sociable Cider Werks, which operates a craft beer and cider house in Minneapolis. It opened on Black Friday in 2013. *Sociable Cider Werks.*

Sociable Cider Werks owners Jim Watkins, Wade Thompson and John Kirkman have a simple philosophy about their business: Sociable ciders—those that are well carbonated, dry and always made from real apples—should be enjoyed like great draft beer. The cidery/brewery specializes in using freshly pressed midwestern apples and blending them with a variety of brewed adjuncts and fermented dry to come up with their ciders.

Sociable Cider Werks began as a garage operation run by Watkins and Thompson, who both have family ties to the world of craft ciders. "Wade's father-in-law, Dan, has been a long-time home cider maker," Watkins said. "Our first test batches of Freewheeler were actually iterations of Dan's Normandy style ciders."

Watkins added that his "maternal grandfather was known to explode barrels of homemade basement root beer, and his paternal grandfather was a hobby beekeeper and mead maker in Austin, Minnesota."

On Black Friday 2013, Jim and Wade officially chucked the corporate world and opened their craft cider/beer house at 1500 Fillmore Street Northeast in Minneapolis's Nordeast brewing district. As of this writing, Sociable Cider Werks was producing about five hundred barrels a month or about six thousand barrels annually. Jim said his company hopes to boost that production to about eight to nine thousand barrels in 2019.

Business hours: Mondays 4:00 p.m.–10:00 p.m.; Wednesdays 4:00 p.m.–10:00 p.m.; Thursdays 4:00 p.m.–11:00 p.m.; Fridays 4:00 p.m.–12:00 a.m.; Saturdays 12:00 p.m.–12:00 a.m.; Sundays 11:00 a.m.–9:00 p.m.

Specialty brews: Sociable Cider Werks takes what it says is a "Decidedly Different"™ approach to brewing with apples, allowing them "flexibility to make a wide range of unique products that nobody else in the country does." Watkins said some examples of that flexibility and creativity include Spoke Wrench Java Apple, with its brewed chocolate malts and cold pressed coffee, and Ringo Sake Apple, with its brewed koji rice adjunct.

Website: sociablecider.com

Steel Toe Brewing

Steel Toe Brewing opened its doors in August 2011 in St. Louis Park, with the family-owned business focused on brewing and serving "consistent expert-crafted beer."

Located at 4848 West Thirty-Fifth Street, Steel Toe has posted steady growth and is producing close to four thousand barrels of beer annually according to owner Jason Schoneman.

Unlike some microbrewery owners, Schoneman has no plans to take his operation on a growth binge. In an interview with the *Star Tribune*, he said, "When we started, really what it came down to was that I really enjoy the process of making beer. I wanted to continue to do that instead of turning into a manager of people. What I really love is just the physical manufacturing part of this job. And the beer."

Business hours: Mondays 3:00 p.m.–8:00 p.m.; Tuesday through Friday 3:00 p.m.–10:00 p.m.; Saturdays 12:00 p.m.–10:00 p.m.; Sundays 12:00 p.m.–6:00 p.m.

Specialty beers: Steel Toe's cadre of mainstay beers include Provider, a golden ale; Size 7, an IPA; Rainmaker, an India red ale; and Dissent, a dark ale.

Website: steeltoebrewing.com

10K Brewing

This microbrewery at 2005 Second Avenue in Anoka gives homage to Minnesota as "The Land of 10,000 Lakes."

"Brewed in the Land of 10,000 Lakes means leveraging as much local resources and labor as possible," according to the brewery's website. "Driving our local economy will drive us. Minnesota centric values means keeping a nice atmosphere will make everyone's experience more enjoyable."

10K Brewing opened in 2015 after its owner Jesse Hauf traveled the United States coast-to-coast visiting breweries during the evolution of the "Surly bill."

An entrepreneur at heart, Hauf knew that his hometown of Anoka was ripe for a microbrewery. 10K began business with a modest three-barrel brewhouse. "We have gone from 1 to 3 batches per week to a steady 4 batches per week," Hauf said, noting that yields twelve barrels a week for the taproom.

This microbrewery gives homage to Minnesota as "The Land of 10,000 Lakes." *10K Brewing.*

Business hours: Wednesdays 4:00 p.m.–10:00 p.m.; Thursdays 3:00 p.m.–10:00 p.m.; Fridays 3:00 p.m.–11:00 p.m.; Saturdays 12:00 p.m.–11:00 p.m.; Sundays 12:00 p.m.–8:00 p.m.

Fun fact: Besides being a brewery, 10K Brewing is a free live entertainment venue in the evenings, including trivia, comedy and music.

Specialty brews: Local favorite is Vanilla Oatmeal Milk Stout Loonar Uprising.

Website: 10kbrew.com

Tin Whiskers Brewing Company

Jeff Moriarty and his two founding partners, Jake Johnson and George Kellerman, met at the University of Minnesota as electrical engineering students. Following graduation around 2006, they all found themselves

Left: Jeff Moriarity, co-founder of Tin Whiskers Brewing Company. The microbrewery is in downtown St. Paul. *Author's collection.*

Right: A huge mural adorns a wall at Tin Whiskers Brewing Company's taproom and microbrewery. *Author's collection.*

employed for a small engineering services company in downtown Minneapolis.

As they settled into the routine of downtown work life and frequent after-work forays to Bar 5989 and Pizza Luce for happy hour, the three buddies had plenty of time to discuss their interest in craft beer. As engineers, they saw great connections between the art and science of brewing beer.

Soon their talk turned to action when Moriarity and Johnson bought some equipment to start homebrewing. After four years as homebrewers, the men wondered if they could turn their hobby into a business. It took them four more years before the trio, in 2014, launched Tin Whiskers, 125 Ninth Street East, in downtown St. Paul. Their journey included assembling a two-hundred-page business plan that underwent numerous revisions and two and a half years to arrange financing for the $1.1 million brewery startup.

Tin Whiskers has enjoyed steady growth in its first three years and anticipates producing 2,100 barrels of beer in 2018. "My heart and passion is growing this company and building it up," Moriarty said.

Tin Whiskers's engineering theme is carried out in the rest of its branding, as well, including wall mural art work and brewery merchandise.

Business hours: Monday through Thursday 4:00 p.m.–10:00 p.m.; Fridays 3:00 p.m.–11:00 p.m.; Saturdays 12:00 p.m.–11:00 p.m.; Sundays 12:00 p.m.–8:00 p.m.

Fun fact: All Tin Whiskers' beers are named after electrical engineering terms, reflecting the educational background of its owners. Some examples: Flip Switch IPA, American IPA with deep citrus and grapefruit aroma; Short Circuit Stout, a light-bodied and roasty stout; and Lumen Lager, a sessionable crisp, yet flavorful lager with fresh malt notes and a mild floral hop essence.

Website: twbrewing.com

UTEPILS BREWING COMPANY

Buoyed by crowdfunding, Utepils (pronounced ooh tah pilz) Brewing Company came on tap in February 2017.

This unique funding (the company attracted fifty investing partners) helped the Minneapolis brewery and its president Dan Justesen raise about $1.2 million in six weeks. Most of Utepils's investors are from Minnesota, with a few others from California, Tennessee and Wisconsin.

Utepils is located at 225 Thomas Avenue North, Minneapolis on a seven-acre site for its eighteen-thousand-square-foot brewery, taproom and beer garden. With the sixth-largest brewhouse system in the state, Utepils's site allows the brewery ample room for expansion, Justesen said. "We can grow to [producing] 40,000 to 50,000 barrels annually," he added. "We are scaled to build to that level. We want to be a packaging and production brewery."

Justesen said Utepils produced 2,850 barrels of beer for its ten and a half months of operation in 2017. "Currently, we are producing at an annual rate of about 5,500 to 6,000 barrels," he said. "We are very excited with those numbers."

No stranger to the Twin Cities craft beer scene, Justesen was co-owner of Vine Park Brewing Company for several years until his partner Andy Grage bought him out in 2014. Justesen has also served on the Minnesota Craft Brewers Guild, including a stint as its president.

Business hours: The taproom has winter and summer hours. Winter, the taproom opens at 3:00 p.m. Monday through Friday and 12:00 p.m. on

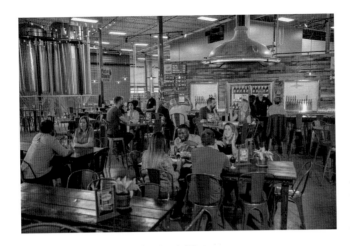

The taproom of Utepils Brewing Company. *Utepils Brewing Company.*

Saturday and Sunday. During the summer, the taproom opens daily at 12:00 p.m. Year-round closing time is Sunday–Thursday 10:00 p.m.; Friday and Saturday 11:00 p.m.

Fun fact: All Utepils's brewery equipment was custom designed in Germany. Additionally, CenterPoint Energy has recognized Utepils for its focus on energy-sustainable operations. Utepils said it has the first North American installed Vario Boil system, which helps cut its energy use by almost 75 percent.

Specialty beers: Utepils's niche is serving classic beers that are accessible to the masses. "Our market is everyone," Justesen said. "We used traditional ingredients with high technology and local water" from the historic Glenwood Springs.

Vine Park Brewing Company

Founded in 1995 by David Thompson, Vine Park Brewing Company touts itself as the only Midwest brewery where customers can brew their own beer and wine with the help of beer coaches. And it is also the nation's oldest brew-on-the-premise brewery and currently one of about a dozen such breweries in the United States.

Vine Park owner Andy Grage's roots in craft brewing date back more than thirty years. "I tasted a Summit Pale Ale in 1990 and was blown away," Grage recalled. "I immediately started homebrewing and was the first employee of the Northern Brewer homebrew shop."

Andy Grage, owner of Vine Park Brewing Company, is a veteran of more than thirty years in the craft beer industry. *Author's collection.*

In 1996, Thompson hired Grage as manager of Vine Park, and in 1999, the business added a brewpub. In 2003, Grage and a business partner Dan Justesen (who is now owner of the Utepils Brewing Company) bought the business from Thompson. In the spring of 2014, Grage bought out Justesen to become sole owner of Vine Park.

Located in St. Paul's West Seventh Street district (between the former Schmidt brewery and the booming Summit Brewery), Vine Park Brewing has averaged 12 percent annual growth in sales since 1995, Grage said, adding that they brew about twelve barrels of beer per month. About 80 percent of Vine Park's brewing is beer, with the rest of its production devoted to wine.

"The beer that we sell in growlers is true to style." Grage said. "Nothing exotic, just clean finishing ales that are brewed to perfection."

Business hours: Mondays 9:00 a.m.–5:00 p.m.; Tuesday through Thursday 12:00 p.m.–8:00 p.m.; Fridays 12:00 p.m.–9:00 p.m. and Saturdays 9:00 a.m.–5:00 p.m.

Fun fact: While Vine Park Brewing tends to cater to the more casual beer drinkers, it has served as a launching pad for some of Grage's interns, who have gone on to work at Lift Bridge, Lucid and other breweries.

Website: vinepark.com

WABASHA BREWING COMPANY

A few blocks south of the Mississippi River at 429 Wabasha Street in St. Paul, Wabasha Brewing Company opened its door in February 2015. Its owners are Chris Kolve, Brett Erickson and Joshua "Tiki" Tischleder, who began in the beer trade as homebrewers. Specifically, Erickson began brewing in his home garage in 2013.

The brewery can produce up to seventy-four barrels per month and expects its capacity to increase to nearly ninety barrels a month. Wabasha

Logo for Wabasha Brewing Company. *Wabasha Brewing Company.*

Brewing started operations with two seven-barrel fermenters and added three ten-barrel fermenters within the last two or three years.

Business hours: Tuesday 4:00 p.m.–10:00 p.m.; Wednesday 3:00 p.m.–10:00 p.m.; Thursdays and Fridays 3:00 p.m.–11:00 p.m.; Saturdays 12:00 p.m.–11:00 p.m.; Sundays 12:00 p.m.–8:00 p.m.

Fun fact: Wabasha Brewing is housed in a building built in 1865. "We exposed the brick, kept the original floors and repainted the original tin ceiling," Kolve said.

Specialty beers: A brew it calls "Westside Popper," a jalapeno cream ale. Its other beers range from pale ale to imperial stout, including three IPAs.

Website: wabashabrewing.com

WAYZATA BREW WORKS

Known as the "Brewery on The Bay," Wayzata Brew Works is located off the shores of Lake Minnetonka at the site of the former Moore Johnson Boatworks.

This microbrewery, owned by businessman Robert Klick, opened in April 2016. "It [the brewery business] started in a small garage and now we have a beautiful [2,500-square-foot] taproom," Klick said.

Klick calls Wayzata Brew Works a "destination location," aimed at serving as a social center for people in the community. "It seems only natural for it to be on the lake." Besides selling beer, the Brew Works features live music.

As of this writing, Wayzata Brew Works was self-distributing within a five-mile radius of its taproom "solely to get our beer out there," said Klick, who grew up in the community and went to Wayzata High School. The company's goal was to produce 750 barrels in its first full year of operation.

Wayzata Brew Works is located off the shores of Lake Minnetonka at the site of the former Moore Johnson Boatworks. *Wayzata Brew Works.*

Unlike some breweries, Wayzata Brew Works has no plans to add any large bottling or canning operations. "Keeping it [breweries] local is the trend," Klick said.

Business hours: Wednesdays through Thursdays 4:00 p.m.–10:00 p.m.; Fridays 2:00 p.m.–12:00 a.m.; Saturdays 12:00 p.m.–12:00 a.m. and Sundays 12:00 p.m.–8:00 p.m.

Fun fact: Klick, an entrepreneur and inventor, has multiple patents and, in 2003, won Oprah Winfrey's "Million Dollar Idea Challenge" with his creation of a kid toy called the "Po Knee," a stuffed horse that a child can ride on a parent's knee.

Specialty beers: Klick said the brewery's focus is on doing light beers and lagers.

Website: wayzatabrewworks.com

WICKED WORT

After helping build several breweries in the last decade in the Midwest for other folks, Steve Carlyle decided to take the plunge and build *his own* brewery.

Carlyle and his wife, Tracy, opened the brewery in late January 2016 at 4165 West Broadway Avenue in Robbinsdale. The brewery has a ten-barrel brewing system.

"Steve's motivation was to create a space for people to come together to enjoy a delicious brew," said Amanda Carlyle.

One distinguishing feature of Wicked Wort is that its taproom is open only for adults age twenty-one and older.

Business hours: Mondays 3:00 p.m.–10:00 p.m.; Tuesday through Thursday 3:00 p.m.–11:00 p.m.; Fridays and Saturdays 12:00 p.m.–12:00 a.m.; Sundays 11:30 a.m.–9:00 p.m.

Fun fact: Wicked Wort's home is in a former TCF Bank building that dates back to 1967. Wicked Wort reconstructed a portion of this old bank into taproom in 2015 and made room for an outdoor patio in the spring of 2016. The taproom features two unique bars from the 1930s and 1940s, giving that space a speakeasy ambience.

Specialty beers: The brewery's signature beers are Birdtown Blonde Ale and Showgirl Raspberry Wheat Ale.

Website: wickedwortbrewingco.com

A Few Casualties

Not every microbrewery survives. Among the many new brewery openings, a few players have succumbed to competition or other issues. Among recent casualties are NorthGate Brewing and Harriet Brewing.

Launched in 2011 by Jason Sowards, a chemical engineer and veteran of homebrewing, Harriet Brewing joined several Minneapolis microbreweries debuting that year. Sowards overcame several challenges to get the brewery off the ground, including initially not finding a bank that would give him a business loan.

In the following years, Harriet Brewing developed a following, partly because people liked its beer and partly because it combined beer with fun events such as musical festivals that Sowards said were not contrived but an extension "of what I love and the people who participate in Harriet Brewing around me love."[70]

But in January 2017, Harriet Brewing shuttered its doors. Sowards made that announcement on the brewery's Facebook page:

> *After six crazy years, it's time to move on. Development plans for our property do not align with Harriet; thus, we've been forced to relocate. After much contemplation, it has become apparent that Harriet can only exist in its current location. Attempting to relocate and repeat would be lame. Relocating would require a new brand and business plan, and, frankly, starting another brewery now seems unoriginal and risky in this saturated market.*

CRAFT BEER AND THE CHALLENGE OF THE CELIAC

everal years ago, amateur homebrewer Dane Breimhorst and his good friend Thom Foss began considering leaving the corporate world to start their own microbrewery.

But early into exploring what it would take to make this big change in careers, the two men from Faribault, Minnesota, got some bad news: Breimhorst was diagnosed with celiac disease, an autoimmune disorder caused by a reaction to gluten.

For the beer-loving Breimhorst, the disheartening diagnosis initially caused him to reassess whether he should continue to pursue his commercial beer-brewing aspirations, let alone even drink beer anymore. After all, the vast majority of beers brewed on the market are made from wheat, barley and rye, all grains that contain gluten.

"Even handling the ingredients—barley, wheat, rye and other grains—would spell trouble for Breimhorst," the *Minneapolis Star Tribune* reported in a news story. "The two would-be brewers were forced to shelve their idea."

However, this is not where their story ends.

While Breimhorst, a professionally trained chef, struggled to come to terms with his medical condition, he and Foss turned their beer search in a new direction. They began researching if there were any gluten-free beers on the market. They started taste testing such commercially available beers. Within a short time, Breimhorst and Foss decided to embark on creating their own gluten-free craft beers.

"We were sampling what was out there on the market after Dane got diagnosed, and most of the beers were American pilsners; they were mimicking Budweiser. There just weren't a lot of options for craft-beer drinkers," Foss told the *Pioneer Press*. "We started Burning Brothers, not only to serve our own need but also to serve the underserved need in the gluten-free community."

Foss and Breimhorst incorporated Burning Brothers Brewing in 2011, concurrent with brewing test batches and developing recipes. (The name "Burning Brothers" comes from when Breimhorst and Foss were fire-eating performers for a few seasons at the late summer Minnesota Renaissance Festival in Shakopee, Minnesota.)

Burning Brothers Brewing began building its brewery in 2013; their first batch was brewed that December and the initial product distributed in January 2014.

"Being the only dedicated gluten-free brewery in the Midwest, all we do is gluten-free beer," the company noted. "Why? We've been there and we

Burning Brothers Brewing, in St. Paul's Midway district, is brewing gluten-free beers. *Author's collection.*

know what you're going through. Our calling is to bring the freedom to drink beer back to everyone who is gluten-free. We want to not only give you that freedom, but to push the envelope and bring you flavors you've never tasted before."[71]

Burning Brothers adds, "We don't use gluten-free filtering, gluten-free enzymes or any other gluten-free gimmicks. Instead we use naturally gluten-free ingredients to create great-tasting and unique beers." In place of the usual grains, Burning Brothers uses sorghum, a grass from Africa's Nile River Valley.

"We use any grain that doesn't have gluten, like millet and buckwheat," Foss said. "We even use quinoa."

Breimhorst is the head brewer and the creative force behind Burning Brothers' styles, flavors and gluten-freeness of its beers while Foss leads the company's operations and finances.

Breimhorst said his experience as a professional chef helped him to learn how to pull out flavors and tastes to delight people's palates. "We use yeast differently, grain differently, hops differently," he said. "We pull out flavors so our beer tastes like we are using barley or wheat."

One challenge in developing gluten-free beer recipes was figuring out how to get rid of the sweet diet soda–like aftertaste from using sorghum, the two men said. "We've cut that sweet tail off the sorghum. We've also eliminated the green-apple taste you tend to get," Breimhorst said.

After working out the kinks to produce their gluten-free beers, Breimhorst and Foss said they are brewing suds they consider to be exceptional. Today, from its St. Paul location (1750 West Thomas Avenue), Burning Brothers produces a relatively small but growing amount of beers.

In 2017, the company produced slightly more than one thousand barrels.

The taproom also has served an IPA, a lager, a lime shandy, a cranberry shandy, a chocolate oatmeal stout, an English mild, a fresh hopped beer, a spiced ale, an imperial stout, a dry stout, a Belgian saison, a Belgian strong ale, a buckwheat ale and a black pepper porter.

In its first year and a half in business, Burning Brothers went from distributing its beer initially in forty locations in one state during its first week of operations to now more than eight hundred locations across six states.

What could have dissolved into a personal tragedy has instead become a glorious new opportunity for gluten-free beer drinkers everywhere! The brewers boast, "We make beer so good that celiacs cry when they taste it."

NEW MODEL FOR MICROBREWERIES

The Beer Cooperative

When home-brewing beer aficionados Evan Sallee, Niko Tonks and Matt Hauck incorporated the Fair State Brewing Cooperative in early 2013, they had no doubt their venture was worth pursuing.

"We saw the [cooperative business] model and knew how solid craft beer was in Minneapolis," Sallee told *Twin Cities Beer*, "and it seemed like [creating the cooperative] it was a no-brainer."

Sallee noted that Minnesotans are very familiar with cooperatives, as the state is the national leader of them. "They [Minnesotans] know cooperatives and believe in them," he said. "We thought that beer and cooperatives had a real interesting relationship."

The year 2011 proved to be a seminal time in the eventual germination of Fair State Brewing. That year, the Minnesota legislature passed the so-called "Surly bill" (named after the Surly Brewing Company), a law allowing breweries to operate taprooms on their premises. The new law was a huge victory for microbrewers because it made it easier for them to sell pints and generate beer sales in their start-ups without an immediate need to shoulder the expenses of distribution.

That same year, the three men visited Black Star Brewing in Austin, Texas, to see how the nation's first brewing cooperative conducted business. Ultimately, Black Star Brewing became the model that Fair State's founders used in the setup of their brewing cooperative.

Since the arrival of Fair State Brewing, another beer cooperative has hit the Twin Cities scene: Broken Clock Brew Co-op, which launched operations

Logo for Fair State Brewing Cooperative. *Fair State Brewing Cooperative.*

in early May 2017 in St. Paul. More about Broken Clock later.

Sallee said the goals of the Fair State Cooperative are basic but important: Brew and maintain high-quality craft beers. Provide good paying jobs. Support the local community.

Lifetime membership in the cooperative is $200. Membership entitles an individual to a variety of perks such as happy hour deals, tasting events and contests for designing new beers for the cooperative.

"We want to provide as much value to members on the front end as possible," Sallee told *Twin Cities Beer.*

A nine-member board of directors governs the cooperative, with three seats up for election each year. Co-op members get to vote for the board of directors and share in any of the cooperative's profits.

In the spring of 2012, Sallee made a significant career decision. Although he had just graduated from law school at Northwestern University in Chicago, he found brewing beer more appealing than writing legal briefs.

"Also, if I waited five years [to get into the microbrewery field], the opportunity would be gone," he added. "This is the year we decided to try it [forming the cooperative] and pull the trigger."

At the founders' party in March 2013 (two months after filing the cooperative's articles of incorporation) to announce plans for starting the brewery, the cooperative had fifty members, mostly family and friends of Salle and Hauck. "From there, it just snowballed," Sallee said. "We held monthly events at bars for meet and greets and meeting in people's backyards to tell them what we were all about."

In November 2013, the cooperative's founders signed a lease to start business at 2506A Central Avenue in Minneapolis. "We felt we had a critical mass of dollars that allowed us" to begin operation," Sallee said. "Our efforts were supported by the Northeast Investment Cooperative; they saw the potential (of the brewery cooperative) for Central Avenue."

The three co-founders also put a lot of sweat equity into the cooperative's startup, doing construction work and not getting paid for a while because cash flow was tight.

A wall mural hung at the Fair State Brewing Cooperative taproom features photos of the co-op's many members. *Fair State Brewing Cooperative.*

By the time of its public opening in September 2014, Fair State Cooperative had some three hundred members (with each of those initial individuals investing about $1,000 apiece in the cooperative). The initial debt and capital investment to launch the brewery cooperative was about $550,000, Sallee said.

Today, Fair State Brewing Cooperative, reportedly the nation's third-largest brewery cooperative, has slightly more than 1,300 members, with most of them from Minneapolis's Northeast district. A smattering of co-op members come from as far away as Iowa and northern Minnesota.

In establishing the cooperative, Sallee said, "I knew this was going to be tough." He particularly worried that the licensing process was going to be onerous. But that proved to be easier than he thought.

Occupying 1,400 square feet at its Minneapolis site along with 900 square feet for its brewery, the cooperative has about twenty employees, including sales representatives, taproom servers, brewers, an events and office manager and a financial operator. Its website is fairstate.coop.

COOPERATIVE EXPANSION

In 2016, Fair State Brewing produced 1,700 barrels of beer, essentially maxing out its brewing capacity at its Minneapolis site. That's why Fair State opened a new forty-two-thousand-square-foot production facility in a warehouse building in St. Paul's Midway industrial district. The estimated $2 million expansion gives Fair State the capacity for a fivefold increase in beer production, co-op officials said.

Although Sallee is confident that Fair State's expansion will pay off because it has enjoyed a steady growth, the cooperative doesn't plan to become a huge craft brewer. "We don't have to reach for the stars to achieve steady and sustainable growth," Sallee said.

Besides its financial success, another indicator of the cooperative's triumph is that it has won numerous craft brewery awards. Its list of honors includes 2015 Craftbeer.com's top 10 new breweries in the world and *Growler* magazine's distinction as the best new brewery in Minnesota. It has also been a best beer winner four consecutive times at the Minnesota Brewer Guild's beer festival. Fair State Cooperative has been also recognized as an innovator in sour beer.

Beer specialties: The cooperative serves a range of beers, from light pilsners to a dark-black German-style beer.

Business hours: Monday through Thursday 4:00 p.m.–11:00 p.m.; Fridays 2:00 p.m.–12:00 a.m.; Saturdays 12:00 p.m.–12:00 a.m.; Sundays 12:00 p.m.–9:00 p.m.

BROKEN CLOCK BREWING JOINS THE CLUB

When Jeremy Mathison began exploring whether people in northeast Minneapolis would be willing to support a brewery cooperative, he first brewed and made available free beer—lots of it—some 550 gallons, to be exact. "We wanted to see how people felt about a community-oriented brewery," Mathison said. The results: Strong support and a lot of excitement.[72]

Broken Clock Brewing Cooperative is a 308(a) organization under the corporate laws of Minnesota. Under this particular model, everyone who becomes a part owner in the cooperative is an equal owner, according to Mathison, who previously was a business consultant but was unhappy in that field.

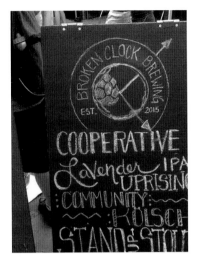

Broken Clock Brewing Cooperative was founded by Jeremy Mathison. *Author's collection.*

Now, Mathison is easily working more hours a day in his new job as the founder and overseer of operations at Broken Clock. But he is much happier.

As of this writing, Broken Clock had nearly four hundred members. Individuals can become lifetime cooperative members for $200. Meanwhile, the minimum amount for a preferred stock investment is $500, and the cooperative is expecting annual returns of 3 to 6 percent from that contribution.

As of the spring of 2018, the cooperative had two full-time employees, two part-time workers and two outside salespersons. "We have now started building out the taproom which will add almost five thousand square feet of space," Mathison told *Twin Cities Beer.* The cooperative also has a staff of about fifty volunteers. In its first year of production, Broken Clock expects to brew about six hundred barrels of beer, Mathison said.

In 2018, the cooperative has the option to build out its operations to thirteen thousand square feet, brewing between two and three thousand barrels of its repertoire of four beers, three offered year-round and the fourth a seasonal brew. A part of the cooperative's community culture is holding beer-tasting events and allowing members to vote on what beers they want to be made and sold.

Another offering of the Broken Clock cooperative is instruction. For $350, members can learn the ins and outs of making the leap from home to commercial brewing. Broken Clock Brewing Cooperative's website is brokenclockbrew.com.

10

WOMEN DO BREWING TOO!

While most microbrewers and brewery owners are men (many of them in their twenties and thirties), a few women are joining their ranks in the beer trade.

Take Deb Loch and her partner Jill Pavlak. They opened Urban Growler Brewing Company in St. Paul's central corridor district in July 2014, becoming Minnesota's first ever women-owned and operated brewery. Their foray into brewing had been years in the making.[73]

Before, Deb and Jill both had successful, steady careers in the corporate world. But they were left with the nagging feeling that there was something better. Deb had been a homebrewer since the 1990s and came from a family that was in the restaurant business. Jill, whose father worked at the Hamm's brewery in the mid-1950s, said that she had always wanted to run a restaurant.

In 2008, the two women decided that someday was now, and that's when the idea for Urban Growler Brewing Company was born. Over the next six years, the two women traveled thousands of miles across the nation, visiting taprooms, finding out about jobs in the industry and attending brew school.

In addition, Deb and Jill spent more than a year raising money to start up their brewery; selling T-shirts, holding beer tastings and offering founding memberships in the business.

CONCEIVING A BIG IDEA

"When we were denied [funding] by over twelve banks, we had to get creative. We found the perfect brewery space, negotiated a reduced rent for one year with hopes of raising a ton of money," Deb and Jill said.

> *We gave tours during that year of our empty brick shell and filled it with architecture drawings, big ideas, hopes and dreams. People came from near and far. They believed in our vision and wanted to help....*
>
> *Together over 50 of them contributed their money, talents and the support we needed to get started. Some of the people were friends and family, others total strangers...at first—now we call all of them friends. We acknowledge their support and belief in us with our Founders plaque on the wall in the taproom. Sometimes it takes a village to make things happen, and Urban Growler is just that.*[74]

Understandably, the debut of Urban Growling was an emotional day for its owners. "Our niche is we designed this brewery with women in mind," Jill said. "We put a bunch of money in HVAC—you will never be too hot or cold in our space. We have purse hooks. Our chairs have square backs so purses can hang without falling off."

Urban Growler Brewing Company is the first woman-owned microbrewery in Minnesota. *Urban Growler Brewing Company.*

As Urban Growler's head brewer, Deb makes traditional beers like CowBell Cream Ale® but also gets creative with the Plow to Pint® series, where local ingredients and the farmers that produce them are featured. Meanwhile, Jill calls herself "co-head honcho," overseeing the company's customer service initiatives and serving as the voice behind its social media.

Located at 2325 Endicott Street in St. Paul, Urban Growler has averaged a 27 percent growth in sales in its first two years. The company produced about 1,200 barrels in 2017 and anticipates brewing over 2,000 barrels in 2018, Jill said.

"More and more women are realizing this [owning and/or operating a brewery] is an option and that you don't have to have a beard to be a brewer," Loch told Thrillist.com. "There's the scientific aspect of it, and there's the creative aspect of it, and both parts are gender neutral. You just have to trust that you can do it."

Since Loch and Pavlak broke ground for Urban Growler, a few other women also have joined Minnesota's brewing industry.

Sarah Bonvallet, co-owner of Dangerous Man Brewing Company with her husband, Rob Miller. When Rob wanted to transform his homebrewing operation business into a full-time business, Sarah joined in the venture, co-writing Dangerous Man's business plan and helping obtain licenses for their company.

Jacquie Berglund, CEO and co-founder of the nonprofit Finnegans Brewing Company (finnegans.org), reportedly the first beer company in the world to donate all its profits to fund fresh produce for people in need. Since its startup, Finnegans has donated more than $1 million toward local hunger relief efforts.

Berglund, former marketing director for Kieran's Irish Pub in Minneapolis, founded Finnegans in 2000 with the goal of making it a philanthropic business. She bought the beer brand Irish Potato Ale from pub owner Kieran Folliard—reportedly for one dollar—and contracted with St. Paul–based Summit Brewing Company to produce the beer. For more than the last decade, Finnegans has contracted with St. Paul–based Summit Brewing Company to produce its beer.

In the spring of 2017, Finnegans announced plans to build Finnegans House, its own taproom and eleven-thousand-square-foot brewery in the Kraus-Anderson's headquarters building project in downtown Minneapolis's Elliot Park neighborhood. Additionally, Finnegans entered into an alternating proprietorship agreement with Badger Hill Brewing

Company of Shakopee that will enable the two companies to coordinate brewing their brands.

Finnegans House debuted on St. Patrick's Day (March 17) 2018.

"I got into the beer industry because of the social business model," Berglund told Thrillist.com. "Trying to make a difference and make the world a better place. That's the core of what we do."

KATHLEEN CULHANE, head brewer and co-owner with business partners ROSEMARY KOSMATKA, ROBIN KINNEY and ERICA ROGERS at the former Sidhe Brewing in St. Paul's Payne Avenue neighborhood.

Culhane's interest in producing beer goes back to 1998, when she started homebrewing in the basement of her house.

After years of dabbling with homebrewing, Culhane went commercial in 2014, opening a two-barrel nanobrewery called Sidhe Brewing. At that time, it was Minnesota's smallest commercial brewer, an operation that Culhane said was bootstrapped and shoe strung together.

Despite its best efforts, Sidhe Brewing had a relatively short run, permanently closing in late March 2017. Culhane blamed the shuttering on a lack of foot traffic and the brewery's hard-to-find location—it was out of the way in the back of a multi-tenant indoor mall called Plaza del Sol, according to news reports.

BEER FESTIVALS

Grab a Drink and Join Your Friends!

The Twin Cities' microbrewery boom has largely been made possible by a critical mass of labor and money. The labor has come from the growing ranks of homebrewers, and crowdfunding is one common way that the new entrepreneurs have raised money for their brewery startups.

But as Doug Hoverson, author of *Land of Amber Waters*, noted, "The other thing that has helped the microbrewery boom is the rise of beer festivals." His observation seemed apropos given that it came during an educational talk at the ninth annual St. Paul Beer Festival, which was held in June 2017 at the Minnesota State Fairgrounds in St. Paul (or more accurately in Falcon Heights) and where more than one hundred vendors turned out for the event.

Beer festivals have become a significant way that Twin Cities commercial brewers support one another and build the broader community of craft beer enthusiasts. On any given weekend, particularly during the summer, one or more beer festivals are likely to be in full swing. Festivals are held by, among others, individual breweries, community groups and industry organizations.

One Twin Cities–based company that is generating a big part of its revenue from beer festivals is Liquid 12 Festivals, doing business as the Beer Dabbler (beerdabbler.com).

Founded in 2008 by Matt Kenevan, the Beer Dabbler holds several beer festivals each year. Its most prominent ones include Pride Dabbler (held in conjunction with Pride Day in Minneapolis), Winter Dabbler (which

Hundreds of craft aficionados turned out for the annual St. Paul summer beer festival at the Minnesota State Fairgrounds. *Author's collection.*

coincides with the St. Paul Winter Carnival) and Summer Dabbler (which is held in late August).

Summer Dabbler attracts more than one hundred breweries offering samples of more than three hundred different kinds of beer. This beer festival is held on the grass at CHS Field, home of the St. Paul Saints minor league baseball team, and draws about 4,500 ticket-buying participants

Kenevan said that a beer festival is a specific event, defined by commercial brewers exhibiting several varieties of their beers to consumers and doing so with other beer vendors under their individual stands or tents. As opposed to a "beer tasting," at a beer festival "you can talk with the brewers and owners," he said.[75]

Kenevan has been in the beer festival business for about ten years. Prior to launching his company, Kenevan helped promote smaller beer festivals while working with Jacquie Berglund and Finnegan Brewing's Finnegan Foundation fundraisers. "We raised money for different charities every quarter. I liked the concept and decided I'd like to take them bigger," Kenevan said, explaining why he launched Liquid 12 Festivals.

Despite its success today, the Beer Dabbler got off to an inauspicious start when Kenevan held his first summer festival in 2008. Rotten weather put a damper on his maiden bash, which was held in a Burnsville parking lot.

"It was horrible weather that day," Kenevan recalled in an interview with *Twin Cities Beer*. "We lost quite a bit of money. I learned from that, that those towns were not ready for this kind of event." From that setback, Kenevan learned to conduct the beer festival within the confines of a larger event, such as the St. Paul Winter Carnival. Now, the Beer Dabbler's major festivals draw thousands of customers.

Besides hosting beer festivals to support the craft beer community, the Beer Dabbler and its parent company Gray Duck Media also operate the Beer Dabbler store and publish a monthly lifestyle magazine called the *Growler*. The Beer Dabbler store, located at 1095 Seventh Street West in St. Paul, carries a variety of local beer-related merchandise, including apparel, glassware, artwork, books and gadgets.

Although not a homebrewer, Kenevan is cut from the same cloth as many microbrewers who have ditched the corporate world to pursue the freedom of the craft beer industry. "I started my business so I could bring my dog to work and wear shorts to work," he said.

Meanwhile, in the Twin Cities, one of the granddaddies of all beer test tastings is the "Land of 10,000 Beers" Craft Beer Hall exhibition at the Minnesota State Fair's Agriculture/Horticulture Building. Sponsored by the Minnesota Craft Brewers Guild, this exhibit features more than three hundred beers from more than seventy-five Minnesota breweries and brewpubs. Visitors get to learn about the craft beer industry and details about the brewing process, "all the way from the farm to the pint glass," according to the Brewers Guild.

Visitors can sample different kinds of beer—from lighter and darker to hoppier and sweeter—when they purchase tickets for a flight of four five-ounce drinks.

Some of the Twin Cities' major beer festivals are:

Autumn Brew Review

In September 2017, the Minnesota Brewers Guild held its seventeenth annual Autumn Brew Review, with more than 120 breweries attending at the historic Grain Belt complex in Minneapolis. The outdoor craft beer sampling event also included live music, table display competitions and beer educational sessions.

City Pages Beer Festival

One of the Twin Cities' oldest annual beer festivals is the City Pages event, which has been around for more than twenty years. Held in the spring, the festival typically features more than sixty brewery vendors, including many familiar Twin Cities names such as 56 Brewing, Bent Brewstillery, Broken Clock Brewing Cooperative, Burning Brothers Brewing, Excelsior Brewing Company, Fair State Brewing Cooperative, Inbound BrewCo, Insight Brewing Company, Lakes & Legends Brewing, Lift Bridge Brewing, Omni Brewing, Sociable Cider Werks, Summit Brewing, Tin Whiskers, Urban Growler Brewing Company and Wicked Wort.

St. Paul Summer Beer Festival

Call it a prelude to the Minnesota Brewers Guild's "Land of 10,000 Beers" Craft Hall exhibit at the Minnesota State Fair, the St. Paul Summer Beer Festival featured more than 120 brewery vendors on the second Saturday in June 2017. Like other festivals, it also features educational sessions, live entertainment and food vendors.

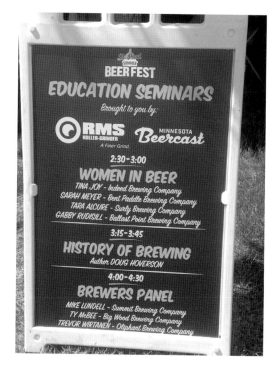

The 2017 St. Paul Beer Festival, held in early June, featured more than 120 vendors and plenty of educational talks. *Author's collection.*

The Brewers Guild has also sponsored "10,000 Minutes of Minnesota Craft Beer," a full week of craft beer events across the state with activities ranging from beer tours to firkin tappings to beer taste testing.

WINTERFEST

This big beer festival is held in February with the most recent one staged at the Union Depot in St. Paul. This event draws several thousand visitors each year.[76] In 2017, the festival was held at the Target Field stadium complex. About one hundred guild member breweries participate. Besides beer sampling, the event also included music, craft beer education and upscale food offerings.

LET'S GO TO
BEER BREWING SCHOOL!

I n the last five years, more than one hundred new craft breweries have opened in Minnesota, with the lion's share of them debuting in the Twin Cities. With that brewery boom have come growing pains for the niche industry, which officials at the Dakota County Technical College in Burnsville learned when they held a brainstorming session to identify growing industries that might need educational support.

"An exploratory team ([rom the Technical College] reached out to the local brewing industry and found that brewery owners were struggling to find candidates with even the basic understanding of how an industrial food production facility operates," recalled Jeff Merriman, currently regional retail manager at Northern Brewer, the largest U.S. homebrewing and wine making company.[77]

Responding to that discovery, the college created and, in August 2015, launched its Brewing & Beer Steward Technology program.[78] It was and continues to be the first and only program of its kind in Minnesota, with Merriman its first lead instructor.

"Through careful collaboration, the brewing industry has communicated the expectations for their ideal candidate and we have designed our program to specifically fit those expectations," Merriman said.[79] The Brewing & Beer Steward Technology's curriculum is a twenty-one-credit, one-year (thirty-two-week) program that is "intended to provide an overview of all aspects of brewing, technical skills and knowledge to select raw materials, production, process management, beer care, beer service, and beer styles

using food pairings," the college notes.[80] Also, "the program is designed to provide operations management, marketing and distribution, and financial management for breweries."

Brewing & Beer Steward students learn, among other things, how to set up, operate and tend brewing equipment and control, adjust and regulate brewing conditions such as material flow, temperature and pressure. They also learn how to validate beer qualities such as clarity, cleanness and consistency; how to maintain logs on instrument readings and test results; and how to clean and sterilize brewery equipment.

"Our goal is to give prospective, entry-level industry workers a base knowledge that will make them a more highly trained candidate than the enthusiastic beer fan," said Merriman, who has more than fifteen years of experience in homebrewing, wine making, mead making and cider making

To date, the beer brewing program has enjoyed strong student support. In its first year, the college filled two sections of students for the program. "Counting this year [2017–18] we'll have about eighty graduates," said Merriman, who has a diploma in brewing science and engineering from the American Brewers Guild in Middlebury, Vermont. Graduates of the program can go on to seek jobs in, among other places, laboratories, brewhouses, brewpubs or small craft breweries.

For information, visit the college's website at http://www.dctc.edu/ academics/programs-majors/construction-manufacturing/brewing-beer-steward-technology.

Not sure if you want to dive head-first into making brewing a full-time career? Or think you just want to be a brewing hobbyist? Then there are less intense beer brewing opportunities. NORTHERN BREWER may meet your needs. The homebrewing supply retailer, which has been in business for more than twenty years, offers a variety of learning opportunities, including "How to Brew Beer–Homebrewing 101" and homebrew classes to beer recipes. Classes and instructional aids cover everything from essential equipment needed for brewing beer, the fermenting process and bottle carbonation to advanced wort chilling, how to build a freezer kegerator to how to make beer. Visit https://www.northernbrewer.com for more information.

Another player in homebrewing education is MIDWEST SUPPLIES, www.midwestsupplies.com.[81] The Twin Cities–based company has a store at 5825 Excelsior Boulevard in Minneapolis that sells a range of homebrewing equipment and offers free introductory classes on how to brew your own beer with starter kits. The retailer boasts that its employees

have years of homebrewing experience and can answer customer questions about homebrewing.

Finally, if you want to brew your own beer but would like a little hands-on help, consider visiting VINE PARK BREWERY, which advertises itself as "the only brewery in the Midwest where you can brew your own beer and make your own wine on our equipment with our help." This St. Paul brewery, located in the West Seventh Street district, has been assisting customers with this firsthand beer brewing help since 1995.

For information on Vine Park Brewery, visit http://www.vinepark.com.

Meanwhile, as the plethora of new craft breweries has fueled the demand for beer brewing education, Merriman acknowledged there is growing discussion in the field whether the Minnesota market is getting saturated. But he chooses to downplay such talk.

"The Brewers Association now reports that there are over six thousand craft breweries in the United States," Merriman noted.

While this seems like an overwhelming number of breweries, I think we can keep the "saturation" discussion to a minimum. After all, there are over four thousand wineries in California. When's the last time you heard someone refer to the wine industry as saturated? Sadly, the craft beer industry does have a fair amount of quality issues. If we see breweries begin to fail, it won't be because there are too many. It'll be a result of poor quality and mismanagement.

Glossary

BEER BANTER

Behind the world of beer brewers is a whole language of their own. Here is a glossary of some of the most common beer terms*:

ABV. Alcohol by volume. This is a measurement of the percent of alcohol present in a volume of liquid.

alcohol. A synonym for ethyl alcohol or ethanol, the colorless primary alcohol constituent of beer. Alcohol ranges for beer vary from less than 3.2 percent to greater than 14 percent ABV. However, the majority of craft beer styles average around 5.9 percent ABV.

ale. Ales are beers fermented with top-fermenting yeast. Ales typically are fermented at warmer temperatures (68 to 75 degrees Fahrenheit) than lagers and are often served warmer. The term *ale* is sometimes incorrectly associated with alcoholic strength.

all-malt beer. A beer made entirely from mashed barley malt and without the addition of adjuncts, sugars or additional fermentables.

barley. A cereal grain that is malted and used in the mash for making beer.

barrel. A standard measure in the United States that is thirty-one gallons. Also, a wooden vessel that is used to age/condition/ferment beer. Some brewer's barrels are brand new and others have been used previously to store wine or spirits.

bock. A very strong lager traditionally brewed in winter to celebrate the coming spring. Full-bodied, malty, well-hopped.

body. The feel of thickness of a liquid in the mouth.

boiling. A critical step during the brewing process during which wort (unfermented beer) is boiled inside the brew kettle. During the boiling, one or more hop additions can occur to achieve bittering, hop flavor and hop aroma in the finished beer. Boiling sterilizes a beer and finishes the enzymatic conversion of proteins to sugars.

Brewers Association. The Brewers Association is an organization of brewers, for brewers and by brewers. More than 2,300 U.S. brewery members and 43,000 members of the American Homebrewers Association are joined by members of the allied trade, beer wholesalers, retailers, individuals, other associate members and the Brewers Association staff to make up the Brewers Association.

brewpub. A restaurant-brewery that sells 25 percent or more of its beer on site. The beer is brewed primarily for sale in the restaurant and bar. The beer is often dispensed directly from the brewery's storage tanks. Where allowed by law, brewpubs often sell beer to go and/or distribute it to off-site accounts.

cask. A barrel-shaped container for holding beer. Originally made of iron-hooped wooden staves, now most widely available in stainless steel and aluminum.

contract brewing company. A business that hires another brewery to produce some or all of its beer. The contract brewing company handles marketing, sale and distribution of its beer while generally leaving the brewing and packaging to its producer-brewery.

craft beer. Beers made by small, independent brewers with only traditional brewing ingredients such as malt, hops, yeast and water and brewed with traditional brewing methods.

craft brewery. According to the Brewers Association, an American craft brewer is small, independent and traditional. A small craft brewery is one whose annual production is six million barrels or fewer.

draught/draft beer. Beer drawn from kegs, casks or serving tanks rather than from cans, bottles or other packages. Beer consumed from a growler relatively soon after filling is also sometimes considered draught beer.

Eighteenth Amendment. The Eighteenth Amendment of the U.S. Constitution established the prohibition of alcoholic beverages in the United States by declaring illegal the production, transport and sale of alcohol (though not the consumption or private possession).

fermentation. The chemical reaction of the yeast consuming the sugars in wort in the case of beer. This process creates ethyl alcohol and carbon dioxide. The two basic methods of fermentation in brewing are top fermentation, which produces ales, and bottom fermentation, which produces lagers.

grainy. Tasting or smelling like cereal or raw grains.

growler. A jug- or pail-like container once used to carry draught beer bought by the measure at the local tavern. Growlers are usually half a gal (sixty-four ounces) or two liters (sixty-eight ounces) in volume and made of glass. Brewpubs often serve growlers to sell beer to go. Often a customer will pay a deposit on the growler but can bring it back again and again for a refill. Growlers to go are not legal in all U.S. states.

hard cider. Fermented beverage made from apples.

homebrewing. The art of making beer at home. In the United States, homebrewing was legalized by President Jimmy Carter on February 1, 1979, through a bill introduced by California senator Alan Cranston. The Cranston Bill allows a single person to brew up to one hundred gallons of beer annually for personal enjoyment and up to two hundred gallons in a household of two persons or more of legal drinking age. Learn more from the American Homebrewers Association.

hops. A perennial climbing vine, also known by the Latin botanical name *Humulus lupulus*. The female plant yields flowers of soft-leaved pine-like cones (strobile) measuring about an inch in length. Only the female ripened flower is used for flavoring beer. Currently, there are more than one hundred varieties of hops cultivated around the world. Apart from contributing bitterness, hops impart aroma and flavor, and inhibit the growth of bacteria in wort and beer. The addition of hops to beer dates from 7000 to 1000 BC.

independent craft brewery. Less than 25 percent of the craft brewery is owned or controlled (or equivalent economic interest) by a beverage alcohol industry member that is not itself a craft brewer.

IPA. India Pale Ale. A strong, hoppy pale ale. The style originated in Britain in the nineteenth century and had a high alcohol content and hopping rate, allowing it to survive the long sea voyage to India.

keg. A large cylindrical, metal container that is commonly used to store, transport and serve beer under pressure. In the United States, kegs are referred to by the portion of a barrel they represent, for example, a $\frac{1}{2}$ barrel keg = 15.5 gal, a $\frac{1}{4}$ barrel keg = 7.75 gallons, a 1/6 barrel keg = 5.23 gallons.

lager. Any beer that is fermented with bottom-fermenting yeast at colder temperatures. Lagers are most often associated with crisp, clean flavors and are traditionally fermented and served at colder temperatures than ales. Lagers usually take longer to ferment than ales.

large brewery. As defined by the Brewers Association: A brewery with an annual beer production of over six million barrels.

malt. Processed barley that has been steeped in water, germinated on malting floors or in germination boxes or drums and later dried in kilns for the purpose of stopping the germination and converting the insoluble starch in barley to the soluble substances and sugars in malt.

mash. A mixture of ground malt (and possibly other grains or adjuncts) and hot water that forms the sweet wort after straining.

microbrewery. As defined by the Brewers Association: A brewery that produces fewer than fifteen thousand barrels of beer per year with 75 percent or more of its beer sold off-site.

package. A general term for the containers used to market beverages. Packaged beer is generally sold in bottles and cans. Beer sold in kegs is usually called draught beer.

pilsner. 1) a style of beer, typically, crisp and refreshing, with a light to medium body and a clear, light to deep gold appearance; 2) these also are tall, somewhat thin-walled, sloped glasses with a solid base; their capacity is usually twelve ounces.

Prohibition. A law instituted by the Eighteenth Amendment to the U.S. Constitution (stemming from the Volstead Act) on January 18, 1920, barring the sale, production, importation and transportation of alcoholic beverages in the United States. It was repealed by the Twenty-First Amendment to the U.S. Constitution on December 5, 1933.

regional craft brewery. As defined by the Brewers Association, an independent regional brewery having either an all-malt flagship or has at least 50 percent of its volume in either all-malt beers or in beers that use adjuncts to enhance rather than lighten flavor.

session beer. A beer of lighter body and alcohol of which one might expect to drink more than one serving in a sitting.

sour. A taste perceived to be acidic and tart, sometimes the result of a bacterial influence intended by the brewer, from either wild or inoculated bacteria such as *lactobacillus* and *pediococcus*.

wort. Wort is beer before it becomes beer. After you boil the ingredients together that mixture is called wort.

yeast. Yeast is what makes the alcohol in beer. Yeast eats the sugars in the wort and gives off alcohol and carbon dioxide. (Yeast was first viewed under a microscope in 1680 by the Dutch scientist Anton van Leeuwenhoek.)

*All glossary information drawn from Brew Dudes.com (https://brewdudes. wordpress.com/beer-making-terminology) and CraftBeer.com (https:// www.craftbeer.com/beer/beer-glossary) websites.

NOTES

Preface

1. "List of Minnesota Breweries," Wikipedia, last modified March 28, 2018, https://en.wikipedia.org/wiki/List_of_breweries_in_Minnesota.

Chapter 1

2. Jones, "Pierre "Pig's Eye" Parrant."
3. Brueggeman, "Beer Capital of the State."
4. Ibid.
5. Ibid.
6. Ibid.
7. Ibid.
8. Ibid.
9. Ibid.
10. Ibid.
11. Ibid.
12. Ibid.
13. Ibid.
14. Ibid.
15. Ibid.
16. Ibid.
17. Ibid.
18. Ibid.
19. Ibid.
20. Ibid.

Chapter 2

21. Treacy, "John Orth, Grainbelt Beer."
22. Ibid.
23. Ibid.
24. Gluek Brewing Company, http://www.historyontheweb.org/minnbrew/glueks.html.
25. "History of Grain Belt Beer," Grain Belt Beer, http://grainbelt.com/about-grain-belt-beer.
26. Ibid.
27. "History of Grain Belt Beer."
28. Ibid.
29. "Grain Belt (Beer)," Wikipedia, last modified March 11, 2018, https://en.wikipedia.org/wiki/Grain_Belt_(beer).
30. "History of Grain Belt Beer."
31. Souder, "Minneapolis."
32. Ibid.
33. Ibid.
34. "Grain Belt (Beer)."
35. "History of Grain Belt Beer."
36. Weniger, "Grain Belt Sign."
37. Turtinen, "Gluek's Beer."

Chapter 3

38. Hoverson, *Land of Amber Waters*, 97–121.
39. "Yoerg Brewing Company," Yoerg's Beer, http://yoergbeer.com/yoerg_history1.
40. "History of Grain Belt Beer."
41. Ibid.

Chapter 4

42. Melo, "Flat Earth Brings Beer."
43. Harris, *Paws of Refreshment*, 18.
44. "Hamm's Brewery," Wikipedia, last modified March 15, 2018, https://en.wikipedia.org/wiki/Hamm%27s_Brewery.
45. Brueggeman, "Beer Capital of the State."
46. "Jacob Schmidt Brewing Company," Wikipedia, last modified February 22, 2018, https://en.wikipedia.org/wiki/Jacob_Schmidt_Brewing_Company.
47. Ibid.

48. Ibid.
49. Ibid.
50. Ibid.
51. "Hamm's Brewery."
52. "Jacob Schmidt Brewing Company."
53. Ibid.
54. Ibid.
55. Kimball, "Life Slowly Returns."
56. Melo, "St. Paul Sells Schmidt."

Chapter 5

57. Author interview with Thomas Keim.

Chapter 6

58. Gribbins, "Beer Hunter."
59. Author interview with Mark Stutrud.
60. "Our Story," Surly Brewing, http://surlybrewing.com/destination-brewery.
61. Ibid.
62. Ibid.
63. Fagerberg, "Is Minnesota Brewing a Craft Beer Bubble?."
64. "Our Story."
65. "Surly Brewing Data Profile," Inc. 5000, https://www.inc.com/profile/surly-brewing.

Chapter 7

66. Author's email correspondence with Badger Hill Brewing.
67. Agnew, "Tale and Taste."
68. Author's email correspondence with Big Wood Brewery officials.
69. "About," Fulton Brewery, http://www.fultonbeer.com/about.
70. Premo, "Tap Talk."

Chapter 8

71. "Our story," Burning Brothers, https://www.burnbrosbrew.com/about/our-story.

Chapter 9

72. Author interview with Jeremy Mathison.

Chapter 10

73. "Our Story," Urban Growler, http://www.urbangrowlerbrewing.com/our-story.
74. Ibid.

Chapter 11

75. Author interview with Matt Kenevan of Beer Dabbler.
76. Tuenge, "Minnesota Craft Beer."

Chapter 12

77. Northern Brewer, https://www.northernbrewer.com.
78. Brewing & Beer Steward Technology Program, Dakota County Technical College, http://www.dctc.edu/academics/programs-majors/construction-manufacturing/brewing-beer-steward-technology.
79. Author's email correspondence with Jeff Merriman.
80. Brewing & Beer Steward Technology.
81. Midwest Supplies, www.midwestsupplies.com.

BIBLIOGRAPHY

Chapter 1

Brueggeman, Gary J. "Beer Capital of the State—St Paul's Historic Family Breweries," Ramsey County Historical Society, 1981, http://www.mbaa.com/districts/stPaulMpls/about/Documents/DistrictHistory.pdf.

Jones, Chip. "Pierre 'Pig's Eye' Parrant—One of the First St. Paul Settlers." Minnesota Fun Facts, March 30, 2010, minnesotafunfacts.com/st-paul-history/pierre-pigs-eye-parrant-one-of-the-first-st-paul-settlers.

Yoerg's Beer. "Yoerg Brewing Company." http://yoergbeer.com/yoerg_history1.

Chapter 2

Grain Belt Beer. "The History of Grain Belt Beer: A Legendary Brew Passed Down Through Generations." http://grainbelt.com/about-grain-belt-beer.

Hoverson, Doug. *Land of Amber Waters: The History of Brewing in Minnesota*. Minneapolis: University of Minnesota Press, 2007.

Hughlett, Mike. "After 153 Years, It's Last Call for Gluek Beer." *Minneapolis Star Tribune*, August 4, 2010, http://www.startribune.com/after-153-years-it-s-last-call-for-gluek-beer/99994254.

John Orth and Family Collection at Hennepin County Library/Central Library.

Millett, Larry. *AIA Guide to the Twin Cities: The Essential Source on the Architecture of Minneapolis and St. Paul*. St. Paul: Minnesota Historical Society, 2007.

"Minneapolis Brewing Company." History on the Web, http://www.historyontheweb.org/minnbrew/mplsbrew.html.

Souder, William. "Minneapolis: No More Mr. Nice Guy." *New York Times*, April 1, 1990, http://www.nytimes.com/1990/04/01/magazine/minneapolis-no-more-mr-nice-guy.html?pagewanted=all.

Treacy, Mary. "John Orth, Grainbelt Beer and Architecture that Defines Northeast Minneapolis." *Twin Cities Daily Planet*, June 8, 2011, https://www.tcdailyplanet.net/john-orth-grainbelt-beer-and-architecture-defines-northeast-minneapolis.

Turtinen, Melissa. "Gluek's Beer Was Brewed before MN Was Even a State—Now It's Coming Back." Bring Me the News, May 24, 2017, http://www.gomn.com/news/glueks-beer-brewed-mn-even-state-now-coming-back.

U.S. Department of the Interior. National Register of Historic Places Registration Form. Grain Belt Beer Sign. https://www.nps.gov/nr/feature/places/pdfs/16000511.pdf.

Weniger, Deanna. "Grain Belt Sign Lights Up Minneapolis Skyline Again after 21 Years." *St. Paul Pioneer Press*, December 30, 2017. https://www.twincities.com/2017/12/30/grain-belt-sign-lights-up-minneapolis-skyline-again-after-21-years.

Zoss, Jeremy. "Nordeast: Then and Now," *Growler*, August 1, 2012, http://growlermag.com/nordeast-then-and-now.

Chapter 3

Grain Belt Beer. "The History of Grain Belt Beer: A Legendary Brew Passed Down Through Generations." http://grainbelt.com/about-grain-belt-beer.

Tillotson, Kristin. "Moonshine Memories: Minnesota's Role in Prohibition." *Star Tribune*, November 8, 2013, http://www.startribune.com/moonshine-memories-minnesota-s-role-in-prohibition/231035241.

Yoerg's Beer. "Yoerg Brewing Company." http://yoergbeer.com/yoerg_history1.

Chapter 4

Brueggeman, Gary J. "Beer Capital of the State—St Paul's Historic Family Breweries," Ramsey County Historical Society, 1981, http://www.mbaa.com/districts/stPaulMpls/about/Documents/DistrictHistory.pdf.

Harris, Moira. *The Paws of Refreshment: The Story of Hamm's Beer Advertising*. St. Paul, MN: Pogo Press, 2000.

Hernandez, Elizabeth. "St. Paul's Iconic Schmidt Brewery Sign Will Shine Tonight." *St. Paul Pioneer Press*, June 15, 2014, http://www.twincities. com/2014/06/15/st-pauls-iconic-schmidt-brewery-sign-will-shine-tonight.

Kennedy, Clare. "Urban Organics Grows into Schmidt Site." Finance & Commerce, June 2, 2017, http://finance-commerce.com/2017/06/ urban-organics-grows-into-schmidt-site.

Kimball, Joe. "Life Slowly Returns to St. Paul's Two Shuttered Breweries." MinnPost, April 4, 2013, https://www.minnpost.com/two-cities/2013/04/life-slowly-returns-st-pauls-two-shuttered-breweries.

Melo, Frederick. "Flat Earth Brings Beer Brewing Back to Old Hamm's Site." *St. Paul Pioneer Press*, November 7, 2015, http://www.twincities. com/2013/06/09/flat-earth-brings-beer-brewing-back-to-old-hamms-site.

———. "St. Paul Sells Schmidt Brewery's Rathskeller Building on W. Seventh for $1." *St. Paul Pioneer Press*, June 29, 2017, http://www.twincities. com/2017/06/28/st-paul-sells-schmidt-brewerys-rathskeller-building-on-w-seventh-for-1.

Twin Cities Trapeze Center, https://www.twincitiestrapeze.com.

Chapter 5

Brueggeman, Gary J. "Beer Capital of the State—St Paul's Historic Family Breweries," Ramsey County Historical Society, 1981, http://www.mbaa. com/districts/stPaulMpls/about/Documents/DistrictHistory.pdf.

Green, Loren. "Resurrecting Yoerg—Minnesota's First Beer Is Back." *Growler*, June 28, 2016, https://growlermag.com/resurrecting-yoerg-minnesotas-first-beer-is-back.

Hughlett, Mike. "After 153 years, It's Last Call for Gluek Beer." *Minneapolis Star Tribune*, August 4, 2010, http://www.startribune.com/after-153-years-it-s-last-call-for-gluek-beer/99994254.

Ngo, Nancy. "Yoerg Brewing Co. to Be Resurrected on St. Paul's West Side." *St. Paul Pioneer Press*, September 30, 2016, http://www.twincities. com/2016/09/30/yoergs-brewing-company-st-paul-west-side.

Turtinen, Melissa. "Gluek's Beer Was Brewed before MN Was Even a State—Now It's Coming Back," Go MN, May 24, 2017, http://www. gomn.com/news/glueks-beer-brewed-mn-even-state-now-coming-back.

Williams, Nick. "Gluek's Beer Making a Comeback in the Twin Cities." *Minneapolis-St. Paul Business Journal*, May 23, 2017, https://www. bizjournals.com/twincities/news/2017/05/23/glueks-beer-making-a-comeback-in-the-twin-cities.html.

Yoerg's Beer. "The Yoerg Saloon." http://yoergbeer.com/the_yoerg_pub.

Chapter 6

Brueggeman, Gary J. "Beer Capital of the State—St Paul's Historic Family Breweries," Ramsey County Historical Society, 1981, http://www.mbaa.com/districts/stPaulMpls/about/Documents/DistrictHistory.pdf.

Crowell, Chris. "From Cutting Government Tape to Ground Breaking Ribbon: The Surly Brewing Story." Craft Brewing Business, October 31, 2013, https://www.craftbrewingbusiness.com/news/cutting-government-tape-ground-breaking-ribbon-surly-brewing-story.

Fagerberg, Jerod. "Is Minnesota Brewing a Craft Beer Bubble?" City Pages, October 5, 2016, http://www.citypages.com/restaurants/is-minnesota-brewing-a-craft-beer-bubble/395859051.

Gribbins, Keith. "Beer Hunter: The Movie about Industry Icon Michael Jackson Is Now Available for Brewery Screenings." Craft Brewing Business, May 8, 2013. https://www.craftbrewingbusiness.com/news/beer-hunter-the-movie-about-famed-beer-journalist-michael-jackson-is-now-available-for-brewery-viewings.

Halter, Nick. "How Mark Stutrud Started Summit Brewing." *Minneapolis–St. Paul Business Journal*, November 25, 2013, https://www.bizjournals.com/twincities/news/2013/11/22/how-mark-stutrud-started-summit.html.

Inc. 5000. "Surly Brewing Data Profile." https://www.inc.com/profile/surly-brewing.

Painter, Kristen Leigh. "12-Ounce Cans? Minneapolis-Based Surly Goes Retro with Beer Packaging." *Minneapolis Star Tribune*, April 7, 2017, http://www.startribune.com/surly-will-introduce-12-ounce-cans/418567883.

Surly Brewing "Our Story." http://surlybrewing.com/destination-brewery.

Chapter 7

Agnew, John. "A Tale and Taste of Barley John's in New Brighton," *Star Tribune*, August 6, 2016. http://www.startribune.com/a-tale-and-taste-of-barley-john-s-in-new-brighton/391893221.

Anderson, Ryan. "Harriet Brewing to Close in Early 2017." MNBeer, November 1, 2016, http://mnbeer.com/2016/11/01/harriet-brewing-to-close-in-early-2017.

Badger Hill Brewing Company, badgerhillbrewing.com.

Bad Weather Brewing Company, badweatherbrewery.com.

Barley John's Brewpub, barleyjohns.com.

BeerAdvocate Staff. "Class of 2016: 34 of the Best New Breweries in the US." *BeerAdvocate*, https://www.beeradvocate.com/mag/14961/class-of-2016-34-of-the-best-new-breweries-in-the-us.

Bent Brewstillery, bentbrewstillery.com.

Big Wood Brewing, bigwoodbrewery.com.

Dangerous Man Brewing Company, dangerousmanbrewing.com.

Excelsior Brewing Company, excelsiorbrew.com.

Fulton Brewing Company, fultonbeer.com.

Green, Loren. "Vine Park Celebrates 20 Years." *Growler*, March 17, 2015, https://growlermag.com/vine-park-celebrates-20-years.

Halter, Nick. "Hopkins First Taproom Opens Saturday." *Minneapolis–St. Paul Business Journal*, June 3, 2014, http://www.bizjournals.com/twincities/news/2014/06/03/ltd-brewing-co-hopkins-taproom-hale-verdon.html.

Hammerheart Brewing Company, hammerheartbrewing.com.

Indeed Brewing Company, inboundbrew.co.

Insight Brewing Company, insightbrewing.com.

Kaufenberg, Brian. "Now Open (or Damn Close): Sisyphus Brewing," *Growler*, March 31, 2014, https://growlermag.com/now-open-or-damn-close-sisyphus-brewing.

Kennedy, Clare. "Now Open: Badger Hill Brewing in Shakopee," *Minneapolis–St. Paul Business Journal*, December 28, 2014, http://www.bizjournals.com/twincities/news/2014/12/26/open-today-badger-hill-brewery-in-shakopee-photos.html.

———. "$1 Million Plus Brewery Planned for Maple Grove," *Minneapolis–St. Paul Business Journal*, June 19, 2015, http://www.bizjournals.com/twincities/news/2015/06/19/1-million-plus-brewery-planned-for-maple-grove.html?ana=twt.

Kerr, Drew. "Now Open (Or Damn Close): HammerHeart Brewing Co.," *Growler*, February 20, 2013, https://growlermag.com/now-open-or-damn-close-issue5hammerheart.

Lake Monster Brewing Company, lakemonsterbrewing.com.

Lift Bridge Brewing, liftbridgebrewery.com.

LTD Brewing, ltdbrewing.com.

LynLake Brewery, lynlakebrewery.com.

Maple Island Brewing Company, mapleislandbrewing.com.

Omni Brewing Company, omnibrewing.com.

Premo, Cole. "Tap Talk: Harriet Brewing Company." CBS Local, April 24, 2015, http://minnesota.cbslocal.com/2015/04/24/tap-talk-harriet-brewing-company.

612Brew, 612brew.com.

Sociable Cider Werks, sociablecider.com.

Steel Toe Brewing, steeltoebrewing.com.

Strait, Patrick. "Sisyphus Brewing Is Going All in on Comedy," *Growler*, January 13, 2017, https://growlermag.com/sisyphus-brewing-is-going-all-in-on-comedy.

10K Brewing Company website, 10kbrew.com.

Tuenge, Ryan. "Northgate Celebrates 3 Years." MNBeer, January 25, 2016, http://mnbeer.com/2016/01/25/northgate-celebrates-3-years.

Utepils Brewing Company, utepilsbrewing.com/beer/brewery.

Wabasha Brewing Company, wabashabrewing.com.

Wayzata BrewWorks, wayzatabrewworks.com.

Weiss, Emily. "Lake Monster Brewing: Five Questions," City Pages, October 4, 2013, http://www.citypages.com/restaurants/lake-monster-brewing-five-questions-6605126.

Wicked Wort Brewing Company, wickedwortbrewingco.com/index.html.

Chapter 8

Agnew, Michael. "Burning Brothers Creates Gluten-Free Beer," *Star Tribune*, March 5, 2014, http://www.startribune.com/burning-brothers-creates-gluten-free-beer/248600271.

Burning Brothers Brewing Company, burnbrosbrew.com.

Fleming, Jess. "Burning Brothers Brewing Bringing Gluten-Free Craft Beer to St. Paul." *St. Paul Pioneer Press*, April 2, 2014, http://www.twincities.com/restaurants/ci_25469636/burning-brothers-brewing-bringing-gluten-free-craft-beer.

Chapter 9

Broken Clock Brewing Cooperative, brokenclockbrew.com.

Fair State Brewing Cooperative, fairstate.coop.

Chapter 10

Fagerberg, Jerard. "Meet The Women Bringing Monumental Changes to the MSP Craft Beer Scene," Thrillist, January 18, 2017, thrillist.com/drink/minneapolis/minneapolis-st-paul-craft-beer-brewers-women.

Fleming, Jess. "Sidhe Brewing Closing, but Owner Will Launch Lowertown Brewery." *St. Paul Pioneer Press*, March 23, 2017, http://www.twincities.com/2017/03/23/sidhe-brewing-closing-but-owner-will-launch-lowertown-brewery.

"Sidhe Brewing to Close on March 25, New Brewery Project Open in Lowertown's Station." *Growler*, March 10, 2017, https://growlermag.com/mill-sidhe-brewing-to-close-on-mar-25-new-brewery-project-opening-in-lowertowns-station-4.

Urban Growler Brewing Company, urbangrowlerbrewing.com.

Chapter 11

Beer Dabbler, beerdabbler.com.

Minnesota Craft Brewers Guild, mncraftbrew.org/events/statefair.

Tuenge, Ryan. "Minnesota Craft Beer by the Numbers." *Growler*, May 6, 2016.

Chapter 12

Dakota County Technical College. Brewing & Beer Steward Technology Program, http://www.dctc.edu/academics/programs-majors/construction-manufacturing/brewing-beer-steward-technology.

Midwest Supplies, www.midwestsupplies.com.

Northern Brewer, www.northernbrewer.com.

Vine Park Brewery, www.vinepark.com.